Historic England

York

Paul Chrystal

AMBERLEY

Acknowledgements
Thanks to Steve Lewis at York Press for the use of a number of photographs from their archive, John Roden for permission to use the Minster School photograph originally published in his *The Minster School, York: A Centenary History 1903–2004*, Tassadar@midlandsheritageforum for the fascinating photograph of Terry's clock, and Yorkshire Architectural and York Archaeological Society for permission to use one of their photographs from the Evelyn Collection. The Evelyn Collection is accessible through YAYAS – www.yayas.free-online.co.uk.

About the Author
Paul Chrystal is a medical publisher, author of many books and a broadcaster. He has appeared regularly on BBC local radio – York, Manchester and Tees – on the BBC World Service and on the *PM* programme. He writes features and book reviews for national newspapers and history magazines. His books cover a wide range of subjects from local and social history to classical history.

www.paulchrystal.com

First published 2017

Amberley Publishing
The Hill, Stroud, Gloucestershire, GL5 4EP
www.amberley-books.com

Copyright © Paul Chrystal, 2017

The following images are the author's own, © York Press, © YAYAS, or with permission of John Roden, Tassadar@midlandsheritageforum, Yorkshire Architectural and York Archaeological Society: 18 (lower), 40 (lower), 56 (lower), 65 (lower), 81–94.

The images on the following pages are © Historic England Archive: 6, 9, 11, 15, 17, 31 (lower), 42, 73, 76–80.

The images on the following pages are © Crown Copyright. Historic England Archive: 14, 16, 18 (upper), 19 (upper), 20, 25, 49, 52.

© Historic England Archive (Aerofilms Collection): 19 (lower). Those on page 74 have been reproduced by permission of Historic England. RIBA.

All other images , unless indicated otherwise, have been reproduced by permission of the Historic England Archive.

The right of Paul Chrystal to be identified as the Author of this work has been asserted in accordance with the Copyrights, Designs and Patents Act 1988.

ISBN 978 1 4456 7528 2 (print)
ISBN 978 1 4456 7529 9 (ebook)

British Library Cataloguing in Publication Data.
A catalogue record for this book is available from the British Library.

Origination by Amberley Publishing.
Printed in Great Britain.

Contents

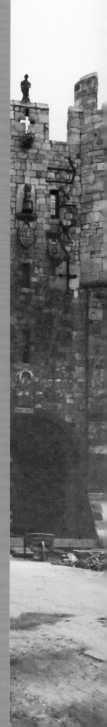

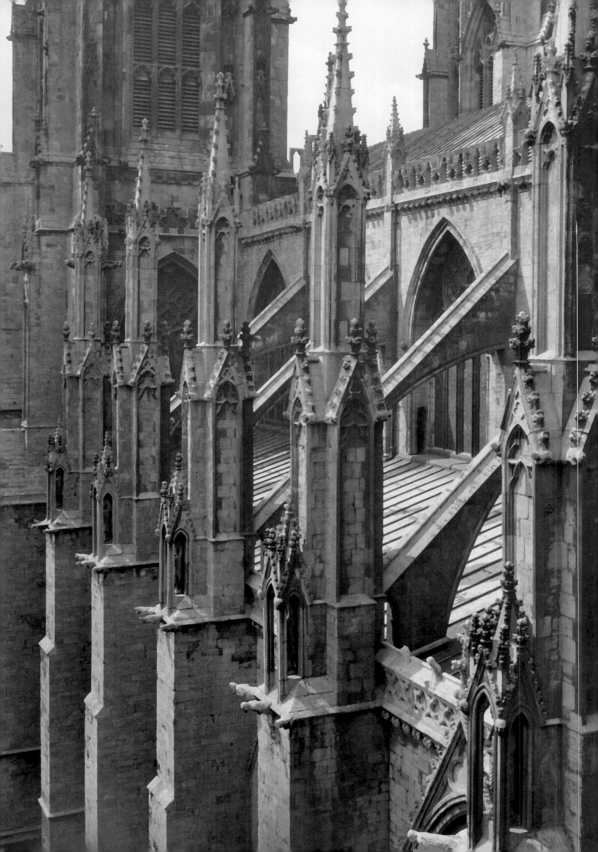

Introduction

There are many books on the history of the city of York, but that is not surprising given that the city can justly claim to be one of the most historically significant places in Europe. This book, however, is different from others because it benefits from having access to the picture archive of Historic England – a wonderful repository of photographs of England – with other pictures coming from the extensive photograph archive of York Press.

The result is a book full of images that have rarely been seen before now. While many of the places depicted are familiar, the images in these pages provide a different, fresh view of them. The book allows us to look through church windows, hear church bells, see mosaics, bridges, rivers, castles, libraries, churches, railway stations and to walk down medieval streets and along medieval city walls. Along the way we meet St William of York, Napoleon, Blind Tom, Princess Anne and Queen Victoria.

Historic England: York casts the city in a new and original light, providing resident and visitor alike with a wonderful perspective of a fascinating city.

Pinnacles and Buttresses, York Minster
Opposite: York Minster is the only cathedral in the county that adorns its altar with holly and mistletoe at Christmas, despite its Druidic connections and the traditional ban on its display in churches. At York it traditionally formed part of a service of repentance where transgressors could seek forgiveness. The priest would hold out a branch and say 'public and universal liberty, pardon and freedom of all sorts of inferior wicked people at the Minster gates and the gates of the city, towards the four quarters of heaven'.

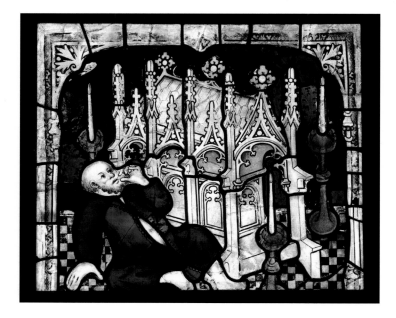

St William Window, York Minster

The magnificent St William window in York Minster, showing a man being cured at the tomb (above), and a woman praying at St William's tomb (below). Both can be seen in the choir, north window. The first bridge to span the Ouse was built by the Romans at the end of what is now Stonegate. The Vikings replaced this in 850 with their wooden bridge. This collapsed in 1154 under the weight of spectators congregating to see the return of St William of York from exile in Sicily after his reinstatement. William made the sign of the cross on seeing the calamity unfold. No one died (one horse suffered a broken leg) and the event was immediately declared a miracle.

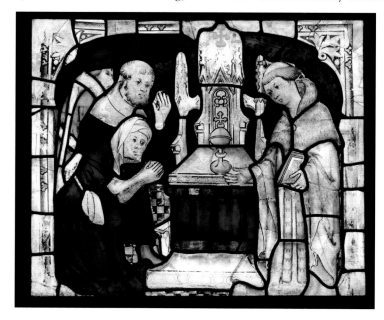

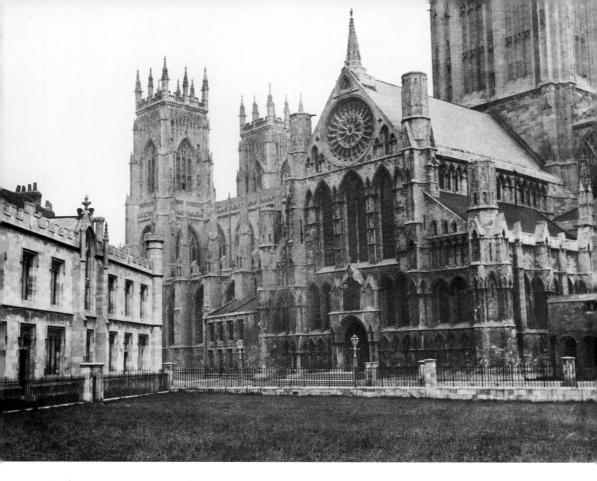

York Minster, Minster Yard

A view of York Minster from around 1858, looking towards the south transept from the green on the south side of Minster Yard. They say all things come in threes; devastating fires at York Minster are no exception. The first was in 1829 when the arsonist Jonathan Martin destroyed the archbishop's throne, the pulpit and the choir. After this the dean and chapter resolved to reinstate the lapsed post of nightwatchman. The second followed in 1840 when clockmaker William Groves left a candle burning and caused the south-west tower to go up in flames. The York Operative Protestants Association were in session nearby and declared it a Catholic hoax. The last was in 1984. Divine retribution was ruled out and an improvident lightning strike was given as the most likely cause. Sadly, the south transept roof was destroyed and the Rose window shattered.

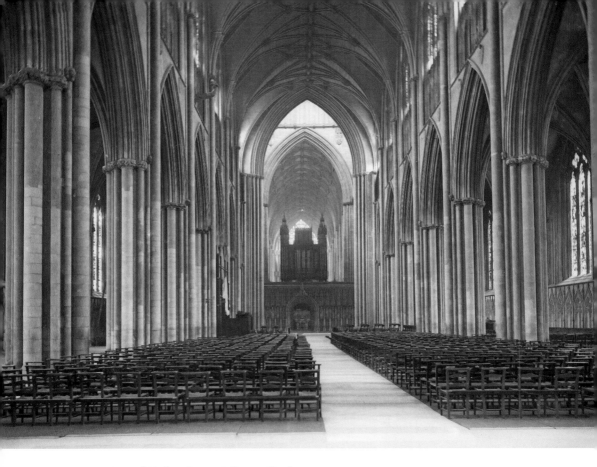

Interior View of York Minster, Minster Yard

An interior view of York Minster, looking east across the nave. York Minster is one of seven cathedrals in the world that have their own constabulary or police force. The others are Liverpool's Anglican Cathedral, Canterbury, Hereford, Chester Cathedral, St Peter's Basilica in Rome (the Swiss Guard) and Washington's National Cathedral. The phrase 'taking a liberty' stems from the police here when, in the thirteenth century, the lord mayor persisted in entering the Liberty of St Peter to harass the residents. The pope intervened to stop him 'taking a liberty'. Today the job of the Minster Police is mainly security, fire watching and looking after the 380 or so sets of keys.

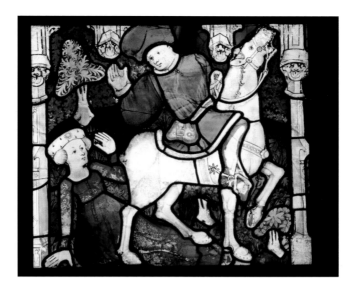

St William Window, York Minster

Details of the St William window of York Minster, depicting a woman being knocked down by a horse (above), and a man imprisoned in the stocks (below). St William, Archbishop William Fitzherbert, nephew of William the Conqueror and Archbishop of York from 1141, was disgraced, vilified by St Bernard ('since many are called and few are chosen') and sacked in 1148. But he was reinstated on appeal by Pope Anastasius IV. William died in suspicious circumstances in 1154 while taking mass in the Minster – perhaps a poisoned chalice? His embalmed head is preserved in York Minster. His sainthood derives as much from the fact that the dean, with one eye on the lucrative pilgrim industry, badly wanted a saint for York to compete with Canterbury's Thomas Becket. In 1227 the pope made William a saint, acknowledging no doubt William's reputation for miracles – mending broken legs and restoring sight – and the fragrant oils that exuded from his tomb.

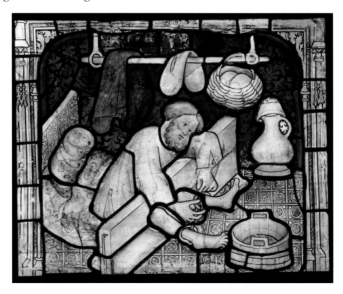

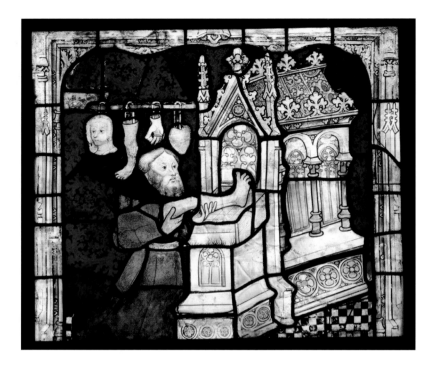

St William Window, York Minster

Details of the St William window, showing a man offering a wax leg at St William's tomb (above) and a man being seized by a devil (below).

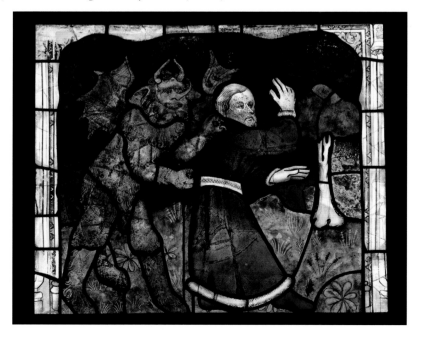

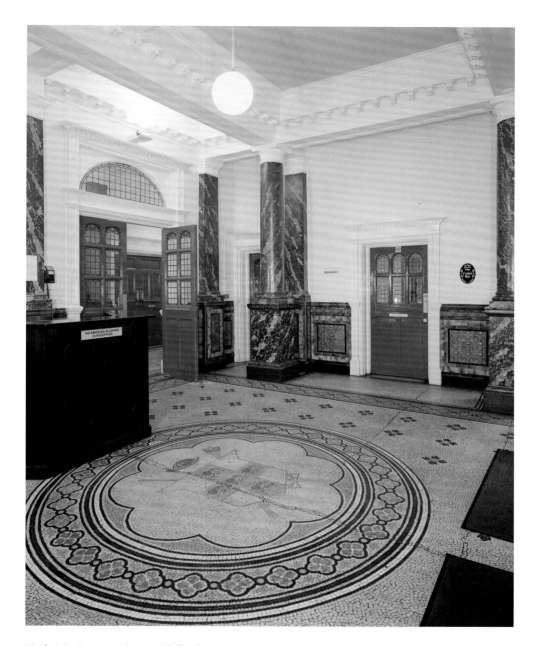

York Magistrates' Court, Clifford Street

The entrance hall to York Magistrates' Court, Clifford Street, viewed from the south-west, including the Armorial mosaics. York had three Water Lanes and they ran from Castlegate, near St Mary's Church, down to the river. They had some of the highest rates of poverty and crime in the city so the Corporation of York decided in 1852 to clear them, demolishing the buildings and creating a new road across where they ran – Clifford Street. Municipal buildings were established on the street, including a new magistrates' court.

St Mary's Tower

St Mary's Tower in 1853 and the adjoining row of houses along Bootham, as seen from the north-east. The tower is also known as Marygate Tower. It was built between 1318 and 1324 as a circular tower and had an original height of over 40 feet. The tower was used to store monastery records after the Dissolution of the Monasteries in 1539. During the Civil War in 1644, however, the Earl of Manchester blew it up with a mine at the Battle of the Bowling Green. The documents that survived were salvaged by Richard Dodsworth and are now in the Minster Library. The tower has been rebuilt.

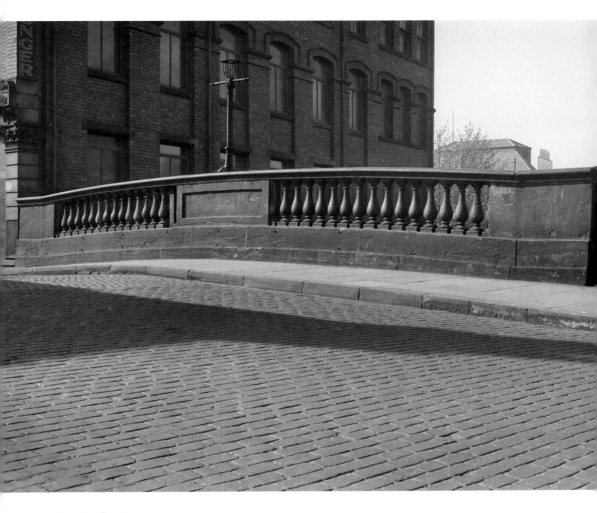

Foss Bridge, Fossgate

A 1944 view looking south-west across Foss Bridge, Fossgate. There were gallows on Foss Bridge administered by the Archbishop of York. Dorothy Wilson's almshouse and schoolroom stood on Foss Bridge. It is now converted to flats, but the building still bears the carved inscription recording the foundation in 1719 of Dorothy Wilson's charity for the 'Maintenance of ten poor Women as also for the instruction in English, Reading, Writing and Clothing of twenty poor Boys for ever'. There is also a memorial tablet to Dorothy Wilson in St Denys Church.

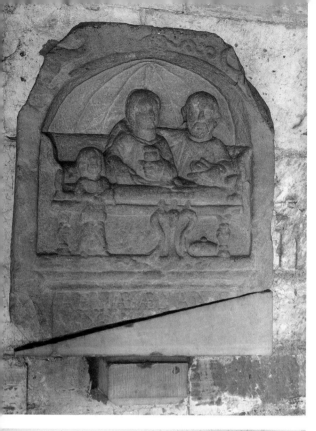

Roman Tombstones

A Roman tombstone (above left, (© Crown copyright. Historic England Archive)) showing man, wife and child, found in 1872 on the old cricket ground north-west of the old railway station. It probably dates to the second century AD. The large second- to fourth-century AD Roman cemetery, consisting of burials and cremations, was destroyed when York's railway station was built in the 1840s. Below left we have another tombstone found at Manor House, Dringhouses, in 1860.

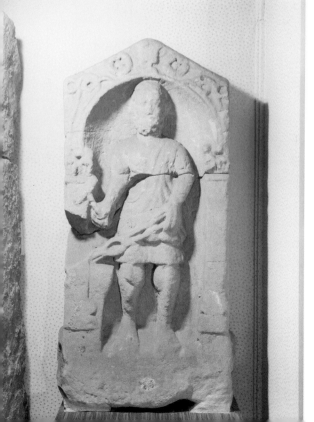

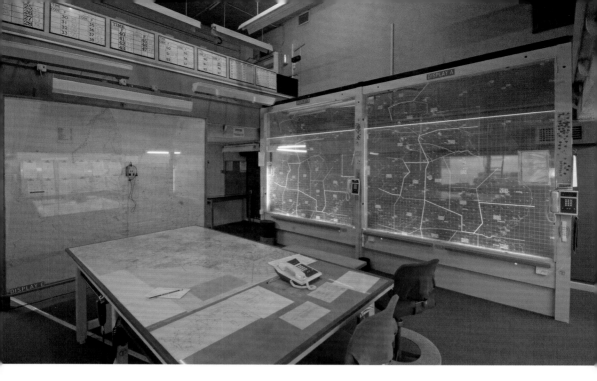

Cold War Bunker, Acomb Road

The image above shows an interior view of the Operations Room at York Cold War Bunker, No. 20 Group Royal Observer Corps Headquarters, Shelley House, Acomb Road. Below is an exterior view of the bunker, showing the steps to the entrance. Opened, or rather closed, in 1961, this piece of Cold War furniture was officially No. 20 Group Royal Observer Headquarters operated by UKWMO, the UK Warning and Monitoring Organisation. Its role was to function as one of twenty-nine monitoring and listening posts in the event of a nuclear explosion. Decommissioned in 1991, English Heritage have opened it to the public to enable them to see the decontamination areas, living quarters, communications centre, and operations rooms.

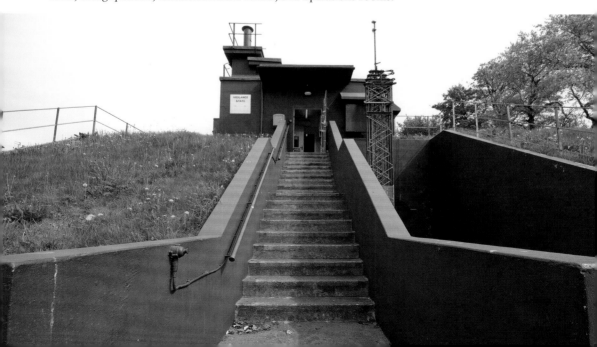

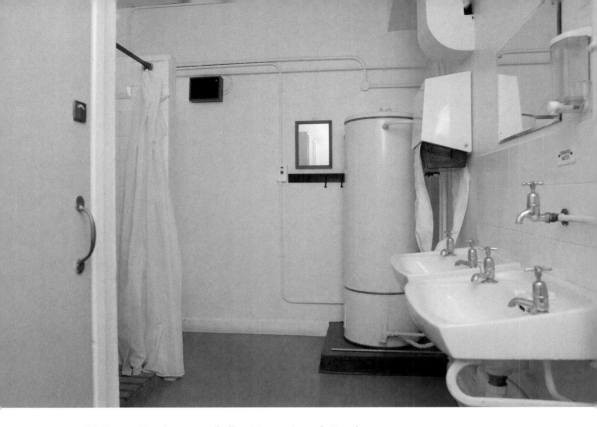

Roc 20 Group Headquarter, Shelley House, Acomb Road
The women's toilet and shower room (above) and the Operations Room at Shelley House (below).

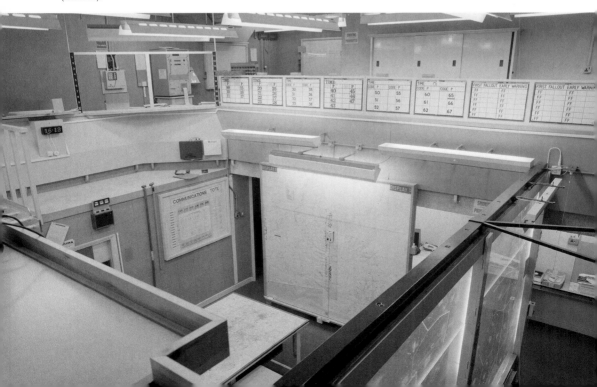

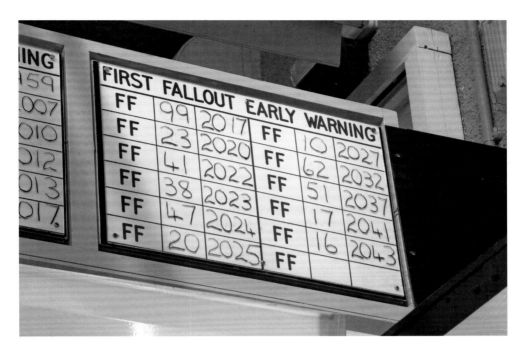

York Cold War Bunker and the York No. 20 Group Royal Observer Corps Headquarters, Acomb Road
Above is a First Fallout Early Warning board at York Cold War Bunker. Below is a view of the Nuclear Burst Tote board in the Operations Room.

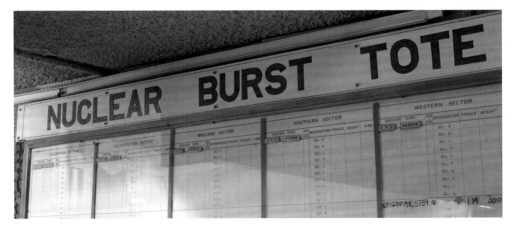

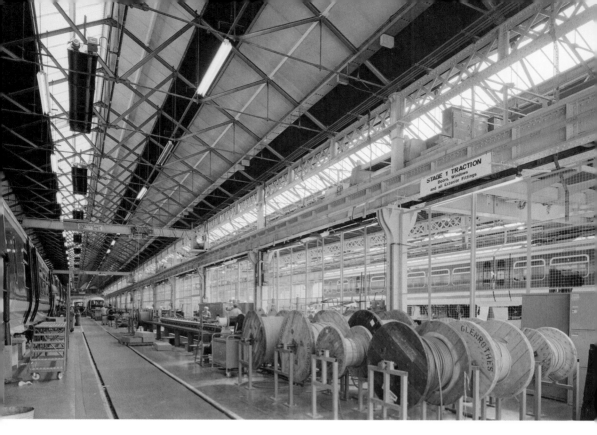

Carriage Works, Holgate Road

The inside of the lifting shop at the carriage works, Holgate Road, in 1995. In 1841 the railway industry in York employed forty-one people. This rose to 513 by 1851 (390 of whom were from out of town, bringing 537 dependents) and by the end of the century NER employed 5,500 workers in York, around half in the carriage works.

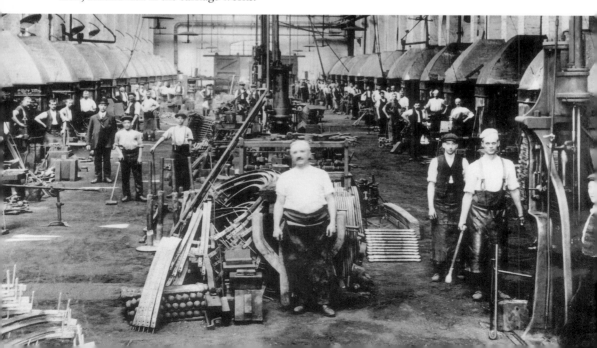

Carriage Works, Holgate Road, and the Railway Station

The image below is York railway station in 1921 and the image on the right shows the carriage works with a carriage. Around 1905 the wagon and carriage works had become more important than the locomotive works. Both had been located in Queen Street until the 1880s when the North Eastern Railway made the decision to concentrate more carriage building in York. New works were therefore built in 1880–81 in Holgate – by 1910 covering an area of 45 acres. The wagon works had been extended in 1864, facilitating the production of up to 100 wagons weekly, with a further extension in 1875 to eventually cover an area of 16 acres.

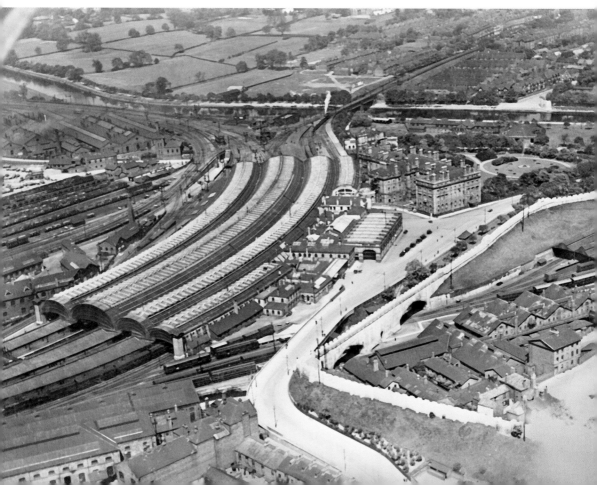

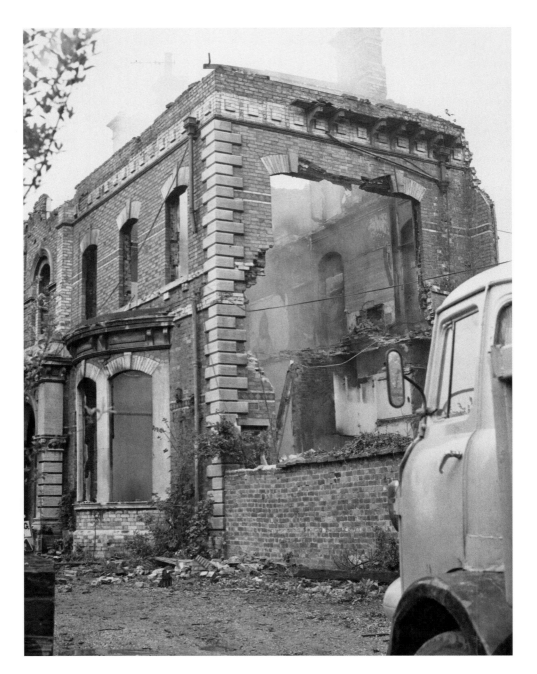

Nunthorpe Hall
Nunthorpe Hall showing fire damage in July 1990. During the First World War the hall was lent to the Red Cross by Sir Edward Lycett-Green for use as a hospital, one of seven York auxiliary military hospitals, opening in October 1915 with fifty beds. It was bombed in 1916 and closed in 1919 having treated 914 patients.

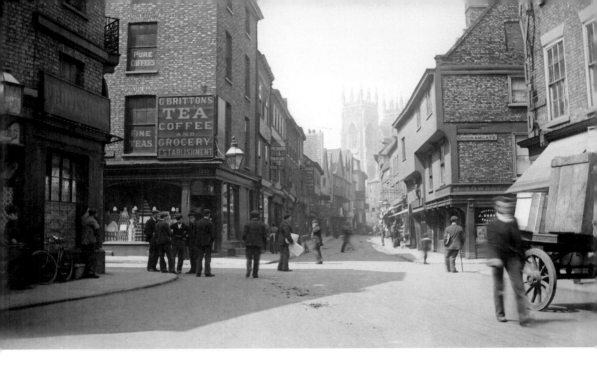

Low Petergate and High Petergate

A view up Low Petergate looking along to York Minster at the junction with Church Street and Goodramgate around 1910 (above). Below we are looking down High Petergate towards Bootham Bar in 1853. Guy Fawkes was born just off Low Petergate. He was baptised at St Michael le Belfry and was a pupil at St Peter's School.

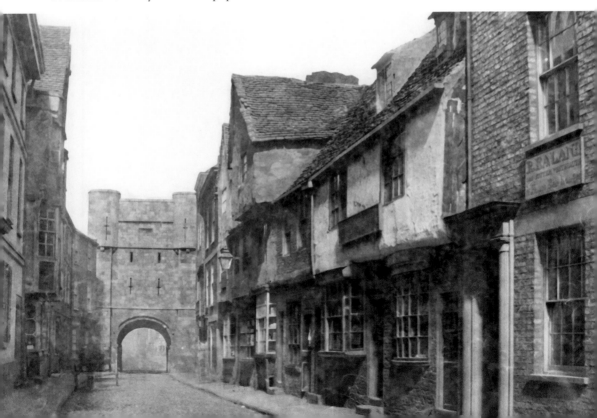

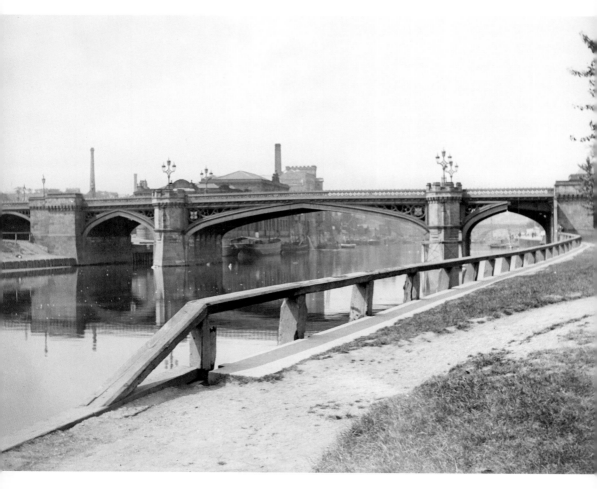

Skeldergate Bridge
A fine view of Skeldergate Bridge in June 1923, in the days when it opened for river traffic. Lendal Bridge is on the right. The York Improvement Act was passed in 1860 to allow construction of the first Lendal Bridge. It was designed by the aptly named William Dredge. Unfortunately, this bridge collapsed during construction killing five men. It was replaced by the present bridge, designed by Thomas Page, who was responsible also for Skeldergate Bridge here and Westminster Bridge.

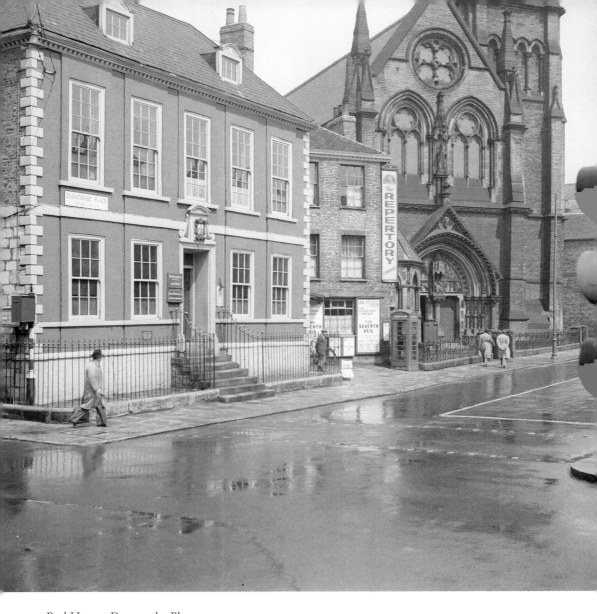

Red House, Duncombe Place

The Red House in Duncombe Place in the 1960s looking towards the corner of the Theatre Royal and St Wilfrid's Church. It was possibly designed by William Etty in around 1700 and dates from 1718. Its candle snuffer can still be seen. Dr John Burton (*Tristram Shandy's* Dr Slop) once lived there and it is now an antiques centre. Burton was a gynaecologist and medical author whose books included *An Essay Towards a Complete System of Midwifery*, illustrated by no less an artist than George Stubbs, who had come to York (then, as now, a centre of excellence in medical science) to learn anatomy. Stubbs found work teaching medical students in the medical school before taking up comparative anatomy, and painting his famous horses. His most celebrated, *Whistlejacket*, was painted in 1762 and featured the very same horse that won the 4-mile chase for 2,000 guineas at the Knavesmire in August 1759.

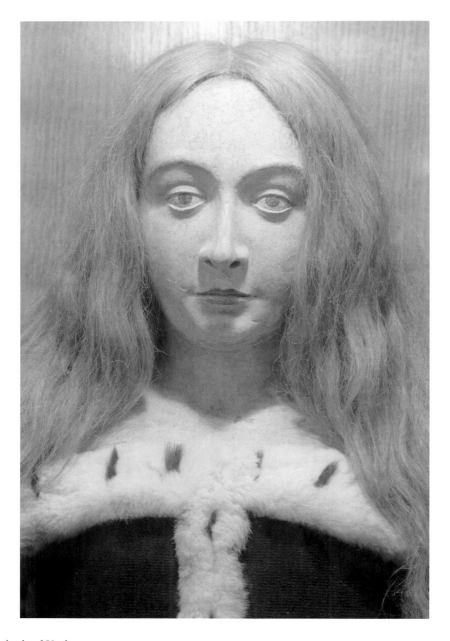

Elizabeth of York
A detail of the funerary effigy of Elizabeth of York, now in the museum at Westminster Abbey. Elizabeth of York (1466–1503) was queen consort of England from 1486 until her death. She was the wife of Henry VII, daughter of Edward IV, niece of Richard III and mother of Henry VIII.

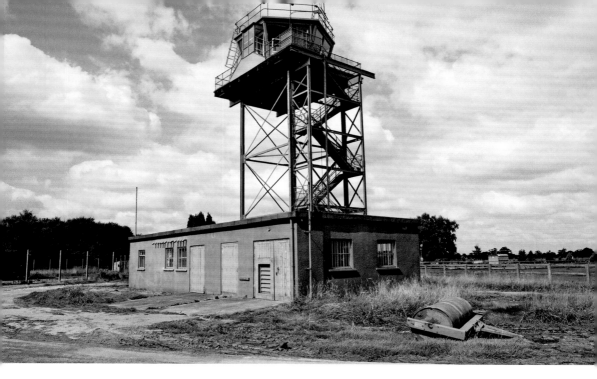

RAF Elvington, Langwith Common

The Control Tower and Approach Control Room at RAF Elvington shot in 1995 (above). The Visual Control Room is shown in detail below. On 10 September 1944 a Halifax from Elvington returned from a raid on Cherbourg-Octeville with a hung-up 1,000-lb bomb. Despite the pilot shaking the aircraft, the bomb was stuck fast only to fall out and explode on touchdown. Six of the crew were killed, but the pilot was blown clear and sustained injuries.

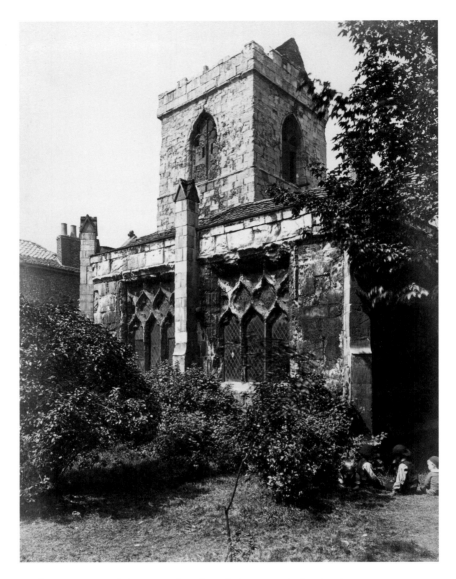

Above and Opposite: Holy Trinity Church and Gateway Arch, Goodramgate
Holy Trinity Church in Goodramgate in 1874, showing the south windows and the tower
(top). Four young boys can be seen sitting next to bushes at the bottom of the photograph.
The bottom image is a view from Goodramgate showing the gates to Holy Trinity Church.
Often overlooked, this treasure of a church can be found through that discreet gateway off
Goodramgate, or through an inconspicuous passage off Petergate. It dates largely from the
fifteenth century, but has features from the twelfth to the nineteenth century. Its features
include the east window with its fine stained glass, donated in the early 1470s by the
Revd John Walker, rector of the church; the box pews, the only surviving examples in York;
and two boards recording the names of lord mayors of the city, including George Hudson,
'The Railway King'.

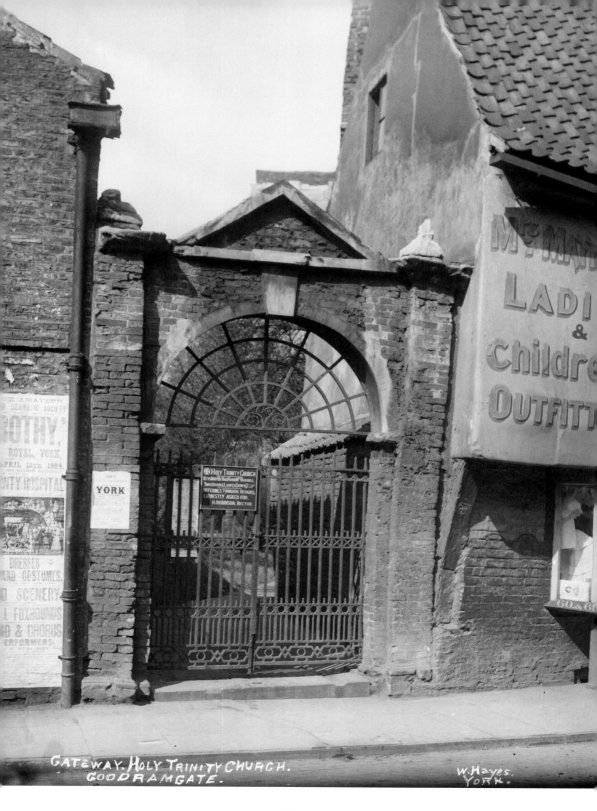

GATEWAY. HOLY TRINITY CHURCH.
GOODRAMGATE.

W. Hayes.
YORK.

27

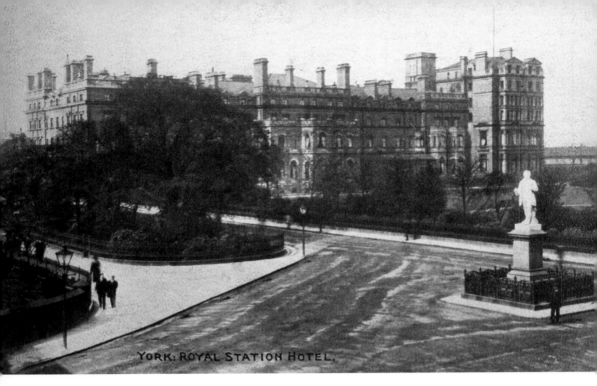

YORK: ROYAL STATION HOTEL.

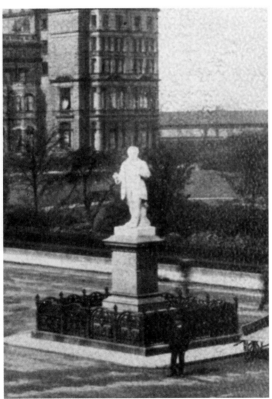

Station Hotel

The Royal Station Hotel, with the statue of George Leeman on the right. Part of the new station project, the Station Hotel opened in 1878 under the management of LNER. A five-storey building of yellow Scarborough brick, it featured elegant, high-ceilinged banqueting rooms and 100 large bedrooms for 14s a night. The twenty-seven-room west wing was added in 1896, named Klondyke after the US gold rush. The hotel was later renamed The Royal York after a visit by Victoria en route to Balmoral. This was York's second Royal Station Hotel – the first had been next to the second station.

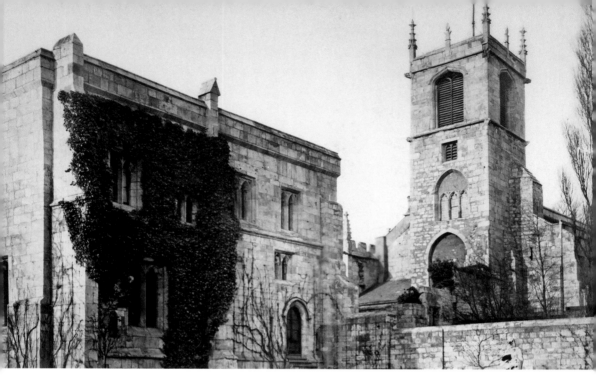

St Olave's Church, Marygate

St Mary's Lodge once formed part of the main gatehouse of St Mary's Abbey. St Olave's Church is the oldest church in the world with this dedication, and is a link to York's Viking past. The chancel was rebuilt in 1887–89 to a design by George Fowler Jones. The image below is of the interior of St Olave's Church showing the south chapel without chairs in 1910.

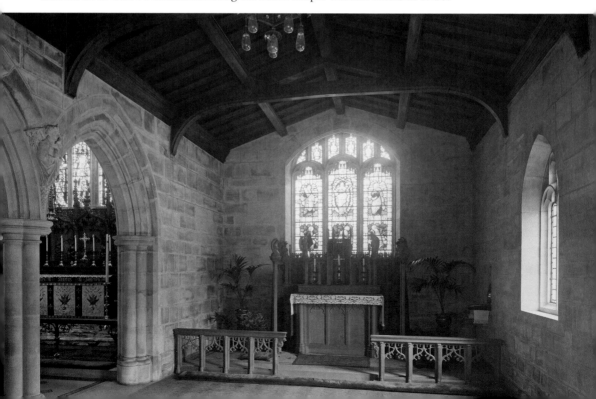

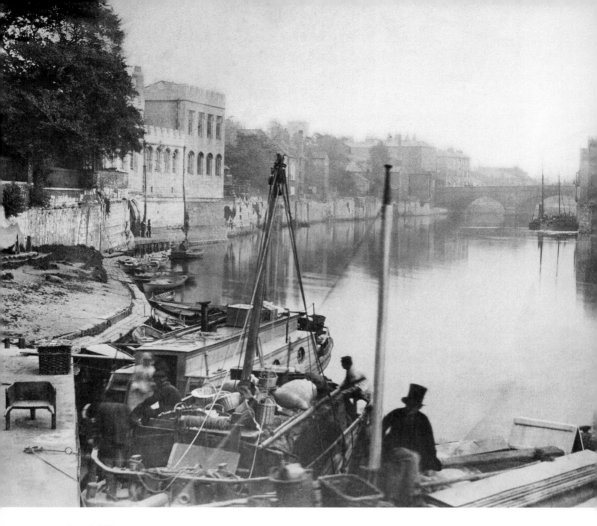

Lendal Ferry

A view looking south-east along the River Ouse, with men loading the boats at the Lendal Ferry in the foreground in September 1854. The Lendal Ferry was a rope ferry between the Barker Tower and the Lendal Tower. It was replaced by Lendal Bridge, which opened in 1863, necessitated by the need for access to the new railway. Jon Leeman was the last ferryman; he received £15 and a horse and cart in redundancy compensation.

Elm Bank Hotel, The Mount
Interior detail of the Elm Bank Hotel, The Mount, showing a decorative overmantel by George Walton.

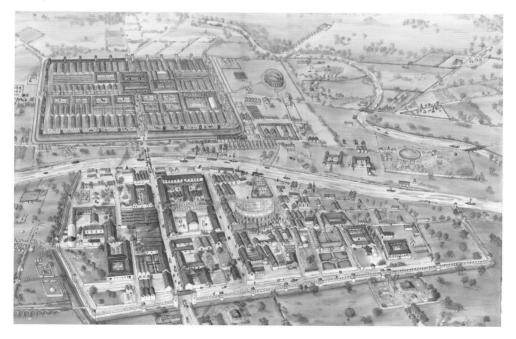

Roman York
A conjectural reconstruction illustration showing an aerial view of Roman York, looking north-east, as it may have looked in around AD 210. Eboracum Legionary Fortress is in the background, with the colonia south-west of the River Ouse in the foreground. (This illustration was reproduced in the book entitled *Roman York* by Patrick Ottaway, published in 1993 by Batsford/English Heritage.)

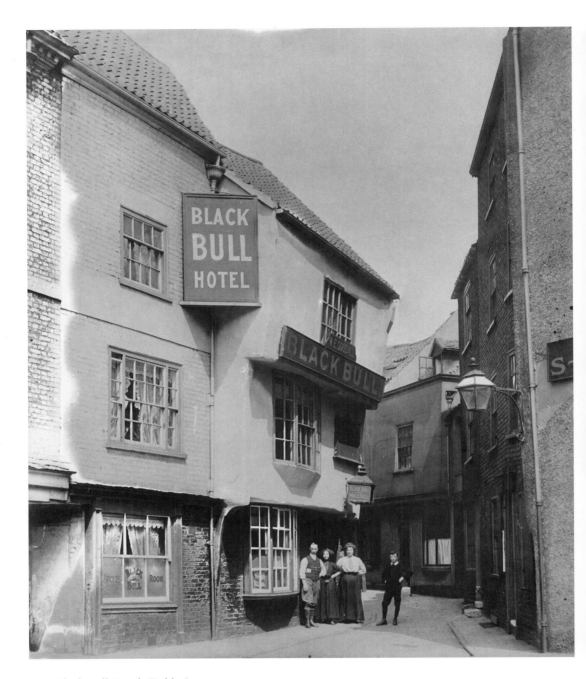

Black Bull Hotel, Finkle Street

The landlord and his family pose for the camera outside the Black Bull Hotel on Finkle Street around 1900. Off St Sampson's Square, Finkle Street was once called Mucky Peg Lane, a notorious haunt for prostitutes – which presumably accounts for the name. An alternative name, though, is Mucky Pig Lane.

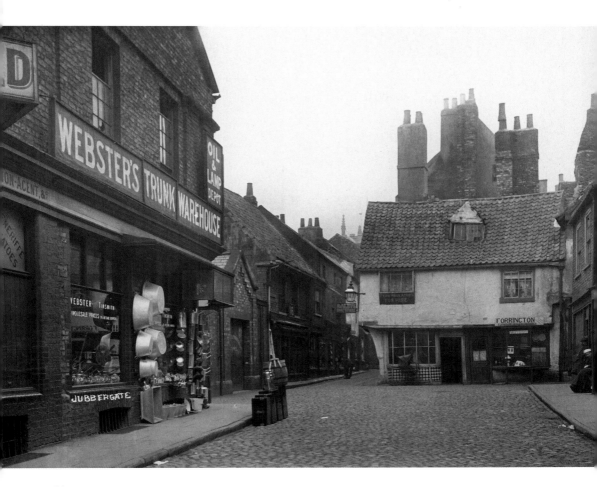

Jubbergate

A view from Parliament Street looking north-east into Jubbergate, showing No. 31–32 Parliament Street to the left, and No. 2 Jubbergate to the right. Originally it was called Joubrettagate – the street of the Bretons in the Jewish Quarter – and Jubretgate. Over the years occupants have included Webster's kitchen- and bath-ware shop (seen here on the left), which became Pawson's, specialists in rubber-ware, and The White Rose Inn, which became Forrington's furnishers around 1920. Jubbergate originally extended to cover what is today Market Street as far as Coney Street. York's first police station was here until 1880 when it moved to Clifford Street.

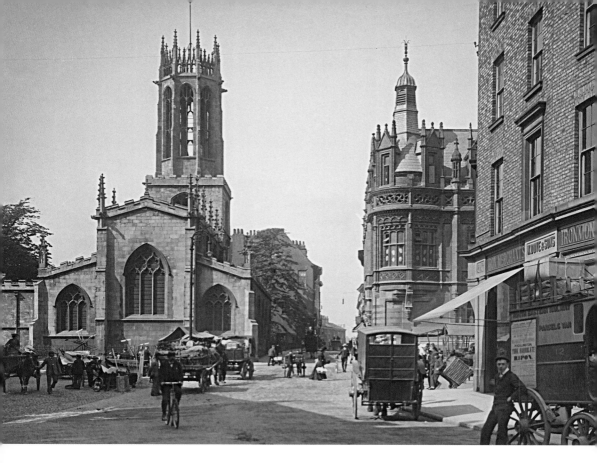

All Saints' Church, Pavement

A William Hayes photograph of All Saints' Church, Pavement, from Parliament Street. 'The stateliest of the York parish churches, thanks especially to the tower.' (Pevsner's *Buildings of England: York and the East Riding,* p. 117)

A church has stood here since before the Norman Conquest, possibly a church built for St Cuthbert in AD 685, superseded by a tenth-century building, but the present building is almost entirely fourteenth and fifteenth century. The most striking feature of the church's exterior is the beautiful octagonal lantern tower dating from around 1400, which for many years beamed out a burning light to guide travellers into York from the surrounding depths of the dangerous Forest of Galtres. Before you can enter the church you have to get past the twelfth-century 'doom knocker' on the door; it is a bronze sanctuary ring depicting in god-fearing detail a bearded man being devoured by a lion – the mouth of Hell. The original is in the York Minster Treasury. All Saints can boast a somewhat gruesome relic claiming to be the plate on which John the Baptist's decapitated head was presented to Herod – another indication perhaps of the church's high status in medieval times.

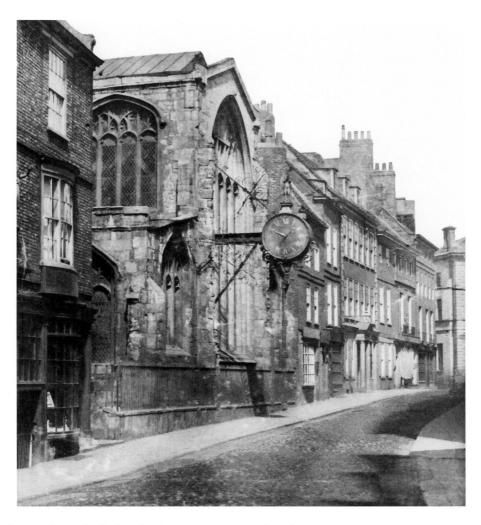

Above and Overleaf: Church of St Martin Le Grand, and Coney Street

Two views from the south-east looking along Coney Street, showing the Church of St Martin le Grand. The bottom photograph shows the front of No. 15 Coney Street with the buildings along the west side of the street, including the premises of John Glaisby's 'Repository of Arts'. 'The best windows had been moved to safety in 1940; the rest exploded into Coney Street forming a glittering mosaic in the molten road.' (Barbara Wilson, *The Medieval Parish Churches of York*, 1998, p. 106)

The largely fifteenth-century building still functions as a church but is also now a moving shrine to all those who lost their lives in the two world wars. St Martin's dates from at least the eleventh century and was one of York's main parish churches. The magnificent Great West or St Martin window (31 feet high and 13 feet wide) was prudently removed at the beginning of the Second World War and was restored resplendent in the south aisle by architect George Pace, where it makes a superb impact. The window was made in around 1447 and shows scenes from the life of St Martin of Tours, including a panel where Martin makes the Devil carry his prayer book.

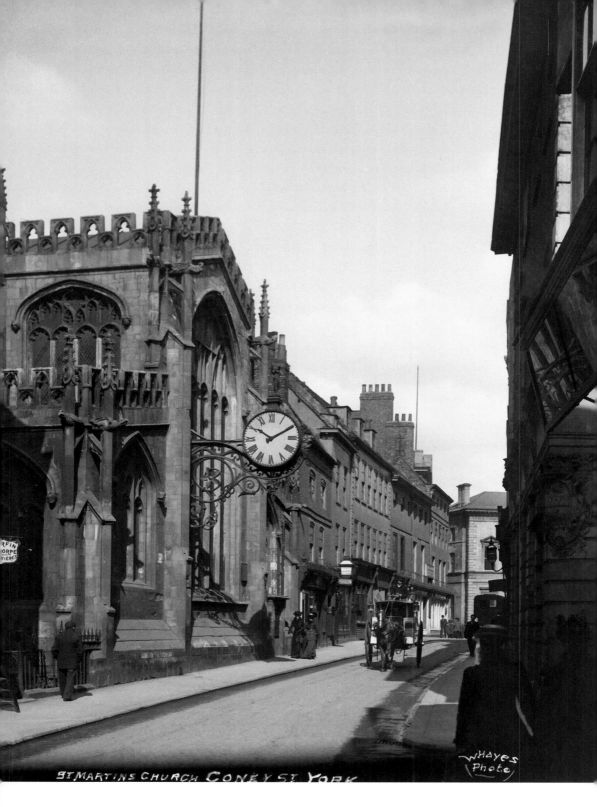

ST MARTINS CHURCH CONEY ST YORK

W HAYES
Photo

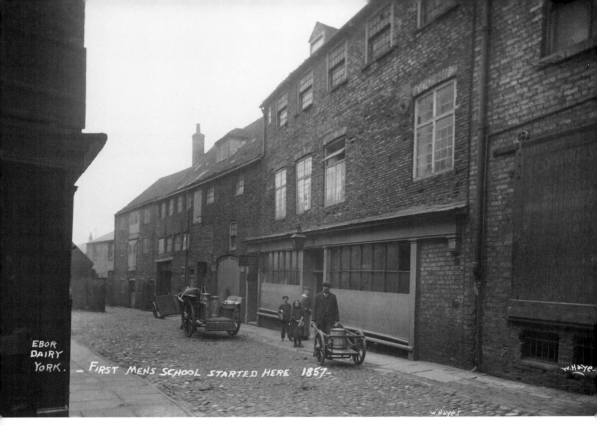

Ebor Dairy, Lady Peckett's Yard

A man with a handcart standing with two children outside the Ebor Dairy in Lady Peckett's Yard around 1902 – a wonderful photograph by William Hayes. The caption refers to the first adult school set up in the yard by the Rowntrees. The Blue Bell is York's smallest pub in Fossgate. It was built in 1798 when the back of the pub faced onto Fossgate and the front was in Lady Peckett's Yard. The Rowntrees were responsible for turning it around in 1903, no doubt because of their adult school in Lady Peckett's Yard. York City FC held their board meetings here and in the Second World War it served as a soup kitchen. Women were barred from the public bar until the 1990s. The item in the handcart is a milk churn.

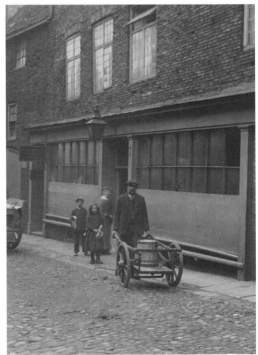

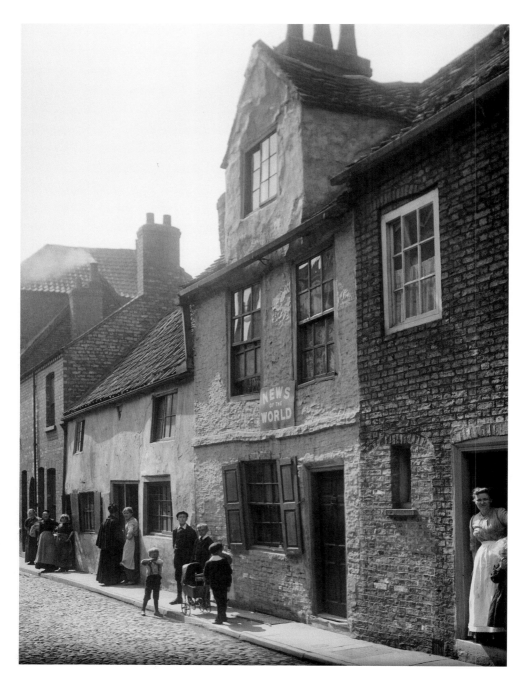

Trinity Lane
Another William Hayes classic with York people on the pavement outside a row of old houses on Trinity Lane, off Micklegate. Jacob's Well is a fifteenth-century timber-framed house in Trinity Lane. It became an inn from 1750 to 1903 called The Jacob's Well.

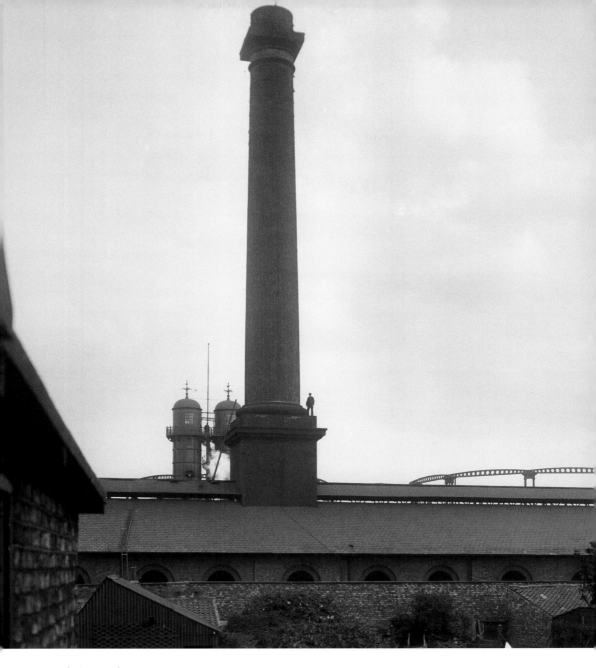

York Gasworks
A 1902 William Hayes view of the chimney at York Gasworks. Gas lighting, or 'the lamp that wouldn't blow out', was introduced to York by the York Gas Light Co. in 1823 on the banks of the River Foss near Monk Bridge. In 1836 the York Union Gas Light Co. was formed. The rivalry was intense, with workmen from the former going round filling in the latter's excavations. The two companies eventually amalgamated in 1843 to form the York United Gas Light Co. In 1824 there were 250 consumers; this had risen to 34,000 by 1963. In 1912 coverage was extended to 7 miles from the Ouse Bridge to take in Haxby, Wigginton and Strensall.

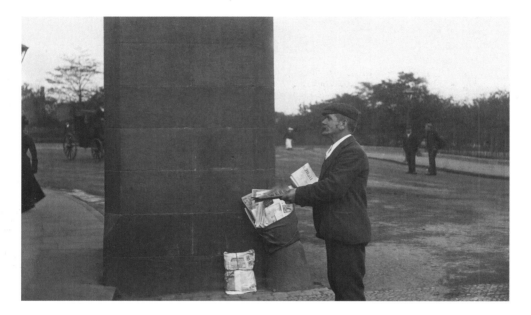

York Newspapers

An unknown man selling unknown newspapers on an unknown street in York. We do, however, know the photographer: William Hayes. The *York Mercury*, York' s earliest newspaper, was printed by Grace White, the owner of her late husband's printing house in Coffee Yard. It was first published on 23 February 1719 but its title then was less pithy: the *York Mercury, or a General View of the Affairs of Europe but more particularly of Great Britain, with Useful Observations about Trade.* Charles Bourne took over the printing house in 1721 and in 1724 Thomas Gent, author of *History of the Famous City of York*, acquired the business. Gent's first issue, for 16–23 November 1724, appeared under the comparatively brief new title *Original York Journal, or Weekly Courant.* By 1728 it was *The Original Mercury, York Journal, or Weekly Courant* and was published until 1739. Below is York's Millennium Bridge over a flooded River Ouse, in December 2013.

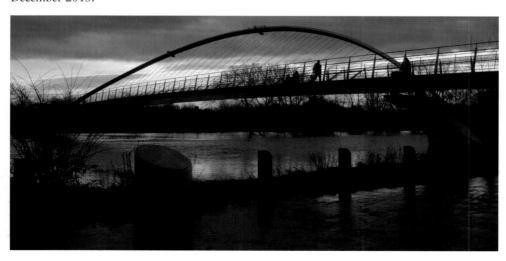

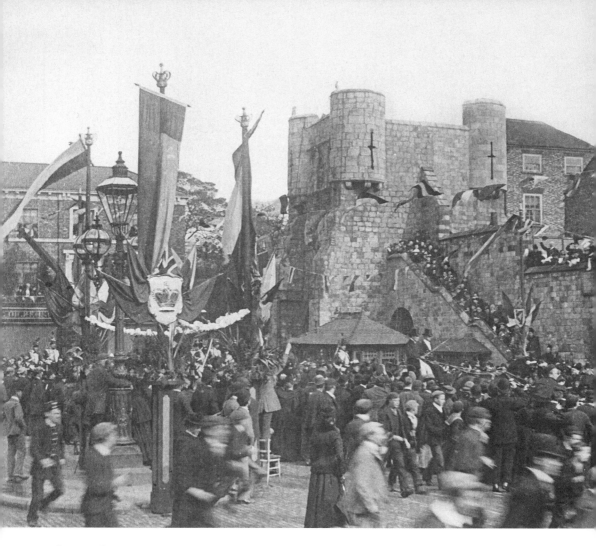

Above and Opposite: Bootham Bar, York

Above is a wonderful William Hayes shot of Bootham Bar in 1897, showing crowds of people celebrating Queen Victoria's Diamond Jubilee. Opposite is the same bar, built on the remains of the Porta Principalis Dextra gateway to the Roman fortress. Bootham Bar (earlier spelt Buthum, which means at the booths and signifies the markets that used to be held here) was originally called Galmanlith. A door knocker was added to the bar in 1501 for the use of Scotsmen (and other outsiders presumably) seeking admission to the city. The barbican came down in 1831 and the wall steps went up in 1889. A statue of Ebrauk, the pre-Roman founder of York, once stood nearby. Thomas Mowbray's severed head was stuck here in 1405 and the Earl of Manchester bombarded the bar in 1644 during the Civil War. The barbican was removed in 1831. The removal of the barbican was due in part to complaints by residents of Clifton, 'not fit for any female of respectability to pass through', on account of the droppings of animals en route to the cattle market and its use as a urinal by pedestrians. The three statues on the top were carved in 1894 and feature a medieval mayor, a mason and a knight. The mason is holding a model of the restored bar.

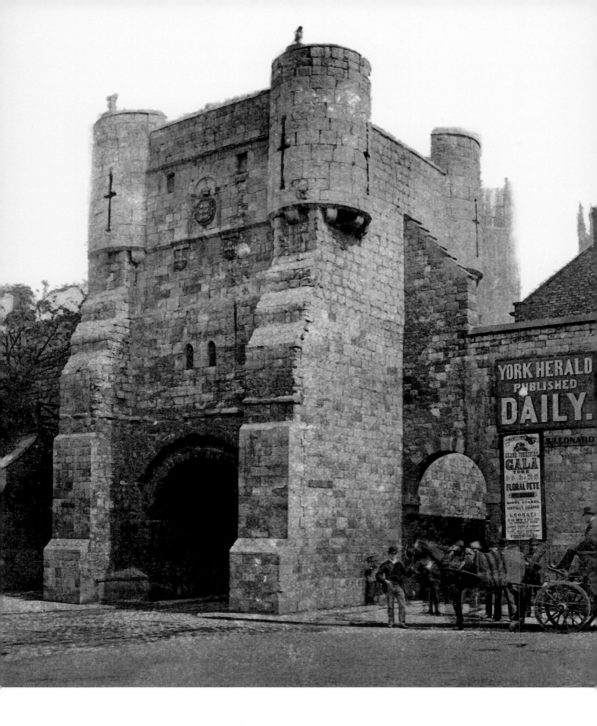

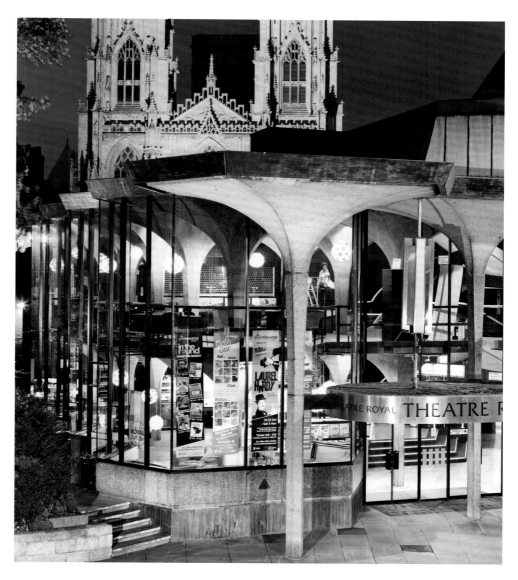

Theatre Royal, St Leonard's Place
St Leonard's Place looking towards the Theatre Royal, illuminated at dusk sometime in 2011, with York Minster behind. The first theatre here was built nearby on tennis courts in Minster Yard in 1734 by Thomas Keregan. In 1744 his widow built the New Theatre here on what was the city's mint, itself built on the site of St Leonard's Hospital. In 1765 it was rebuilt by Joseph Baker and enlarged to seat 550, 'by far the most spacious in Great Britain, Drury Lane and Covent garden excepted', according to the *York Courant*. Access to the site of the mint can still be gained from the back of the main stage. At this time the theatre was illegal and it was not until a royal patent was granted in 1769 and the theatre was renamed the Theatre Royal that this status changed. Gas lighting came in 1824 and in 1835 a new frontage was built facing onto the newly created St Leonard's Place.

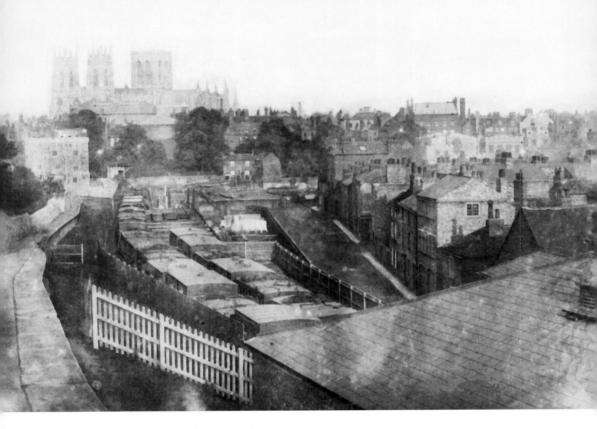

Above and Opposite: Old Railway Station

In 1841 what is known as the Old Railway Station was opened within the city walls. Opening day, 4 January 1841, was a public holiday in York with church and the Minster bells ringing out and huge crowds celebrating the event. Original plans included a booking office facing Tanner Row (costing £7,900), a refreshment room, and a train shed. The large shed, measuring 300 feet by 100 feet, was of iron and glass construction supported by cast-iron columns and was unique at the time. The Italianate facade, facing Tanner Row, was 180 feet long. Access between the platforms came at the head of the tracks – one of the earliest stations in the world with such a facility. The king of Saxony and Charles Dickens were among travelers arriving here. The king visited York in 1844 with Carl Gustav Carus, his physician, who left a detailed account of the stay. The entourage travelled 'by steam' from Liverpool to York. These are two views from the bar walls looking across Lendal Bridge towards York Minster, with railway carriages at the old railway station within the walls in the foreground. The right-hand image was taken in October 1852. Running along the city wall are the coal drops and sidings of the York & North Midland Railway.

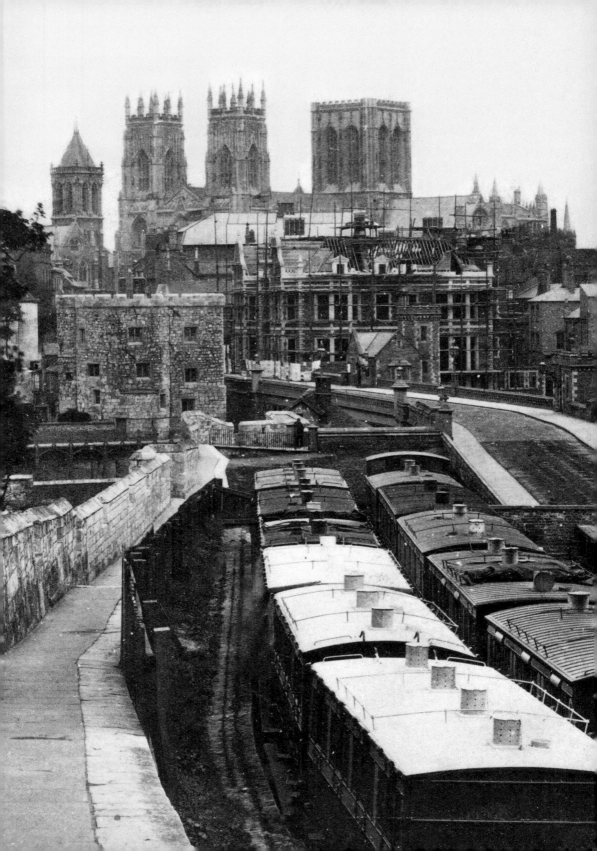

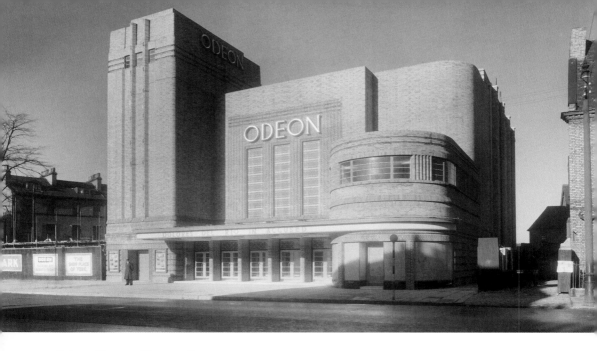

Odeon Cinema, Blossom Street

Odeon Cinema in Blossom Street in the 1937. The inside shot is of the auditorium from the left of the balcony. The Odeon opened in 1937 in Blossom Street on the site of the Crescent Cafe & Dance Salon, typical of Oscar Deutsch's art deco 'palaces for the people'. They were intended to evoke luxury liners and to exude style in contrast to the ordinariness found in most pre-war homes.

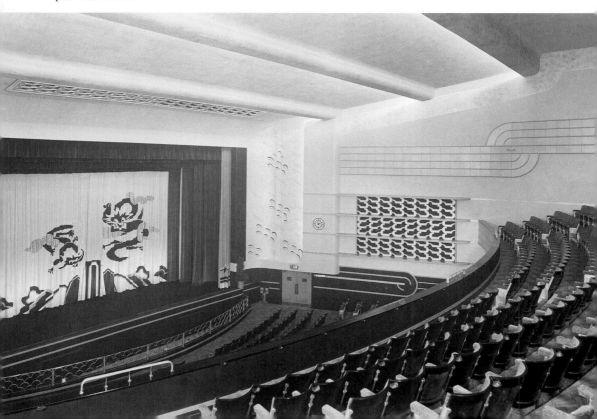

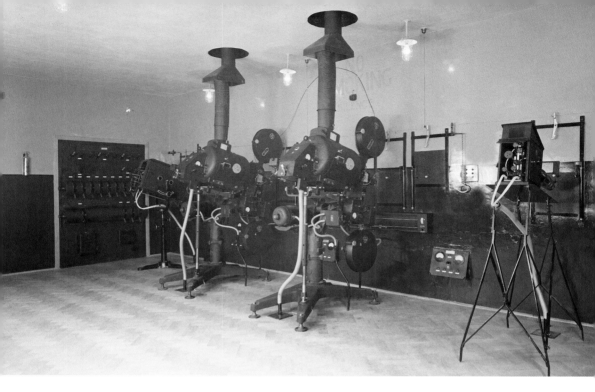

Odeon Cinema, Blossom Street
Above is the Odeon projection box in 1937, and below is the auditorium and orchestra rail.

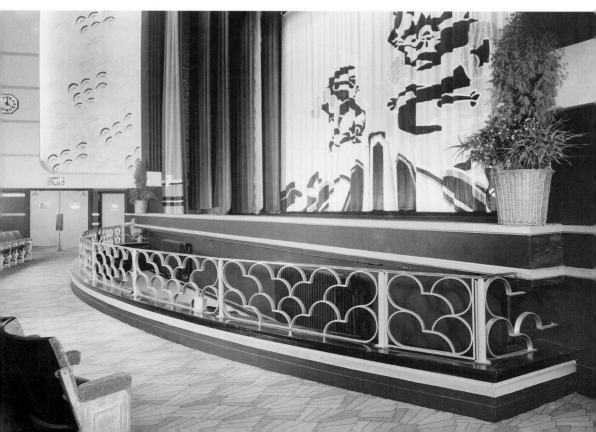

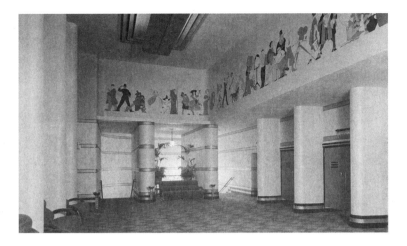

Odeon Cinema, Blossom Street

The Odeon circle foyer in 1987. A Union Flag flew from the roof whenever a British film was showing. It was sometimes said that the Odeon name derives from 'Oscar Deutsch Entertains our Nation'. Not a bit of it: the Odeons were named after the ancient Greek for a building used for a musical performance.

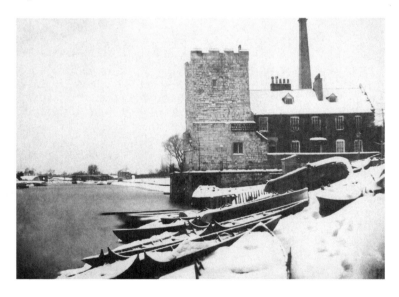

Lendal Tower

This image shows Lendal Tower, before the bridge, in 1853. Looking north-west along the east bank of the Ouse, the offices of the York New Waterworks Co. are shown after a heavy snowfall. The fourteenth-century Lendal Tower was originally a defensive structure. In 1677 the tower was leased for 500 years to the York Waterworks Co. for two peppercorns (a peppercorn rent) and provided York's water supply until 1836 when the dedicated red-brick engine house was built. The tower was put on the market for £650,000 in 2001 and sold as a private residence. The peppercorn rent is payable annually until 2177. The adjoining Lendal Hill House was added in the late eighteenth century.

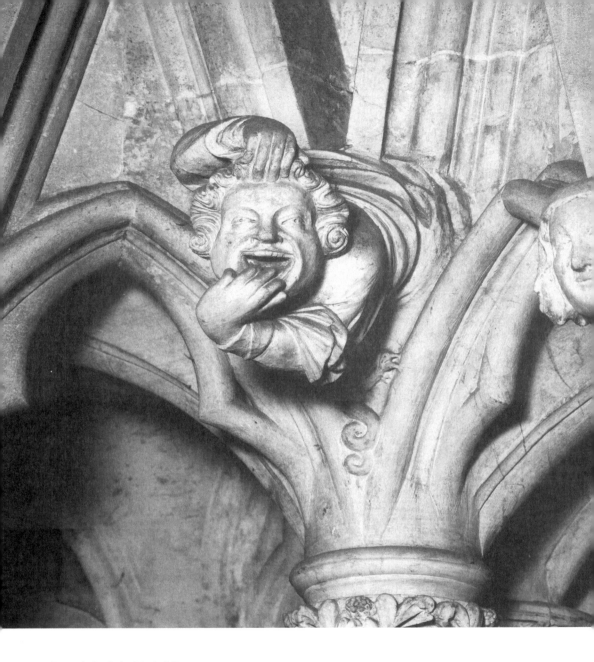

Carved Corbels, York Minster

Two of the many carved corbels in the chapter house at York Minster. 'It has been suggested that the set of figures represent simply an exuberance on the part of the original masons, and should be seen in the context of humorous additions tolerated by the commissioners of the structure, whimsical self-portraits, or expressions of independence of the craftsman over his temporal lords.' (Michael Tyler, *Symbols of Power and Authority: The Iconography of Late Thirteenth-Century Chapter Houses*)

Human heads, animals (monkeys, dogs and boars), puzzling allegorical figures, birds, plant foliage, and these carvings, with the others in the vestibule, make up some of the finest medieval carvings in Europe, if not the world. One depicts a pair of lovers hiding behind one of the capitals.

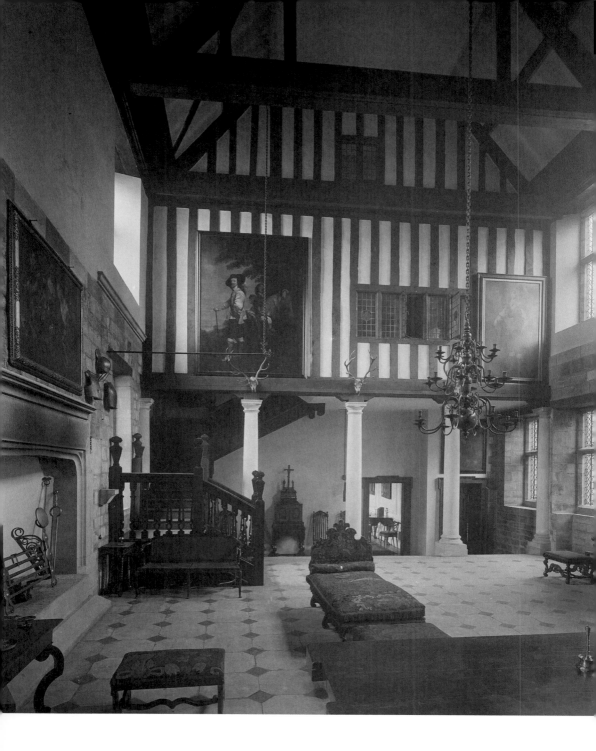

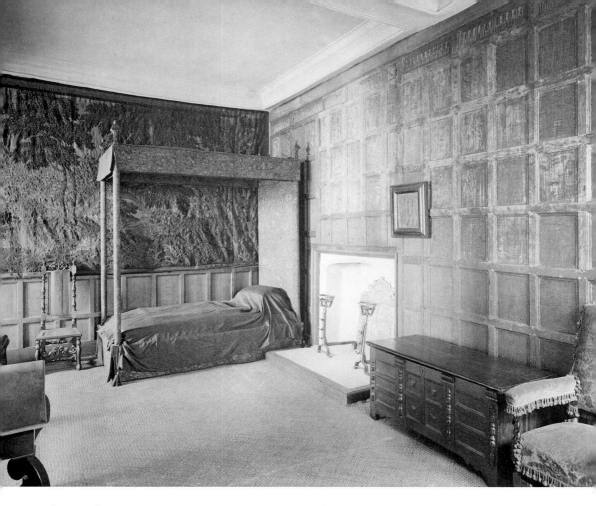

Above and Opposite: Treasurer's House, Minster Yard

The entrance hall in the Treasurer's House looking towards the gallery. The photograph was taken for the owner Frank Green and shows it after restoration work carried out by Temple Moore in 1902. Frank Green, an eccentric, collector and antiquarian, donated the house with all its contents to the National Trust in 1930. Above is the tapestry dressing room. The present house is on the site of a building once used by the treasurer to the Minster until 1547. Radolphus was the first treasurer in 1100. His special house was built on the site of the Roman garrison and was probably razed to the ground in the great fire of 1137. The present building combines a rebuild from around 1300 and a Grade I-listed Jacobean town house with distinctive Flemish gables. Each room is laid out in the style of a different period, as instructed by Frank Green. The Parliamentarian general Sir Thomas Fairfax, of Marston Moor fame, once owned it. By the nineteenth century, though, it was reduced to 'a bug ridden slum'.

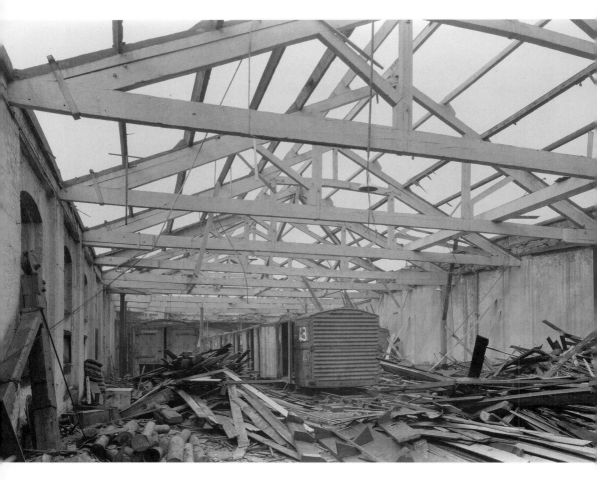

York & North Midland Locomotive Works, Railway Museum, Queen Street, Holgate
York & North Midland Locomotive Works became the first York Railway Museum in Queen Street. This image shows the main shed in April 1979. It was the Science Museum in London – known then as the Patent Office Museum – which started the country's collection of railway artefacts when they purchased *Rocket* in 1866. The North Eastern Railway then opened a public railway museum in Queen's Street, York, in 1927. In the 1930s all the other railway companies had their own railway-related collections, which were all combined in 1948 after nationalisation. In 1975 the National Railway Museum opened in Leeman Road. The 8-foot 10-inch-diameter railway wheels outside are probably the largest locomotive wheels in existence; they were cast at Bristol in 1873 to drive 4-2-4 Tender Loco No. 40, an express passenger train of the Bristol & Exeter Railway.

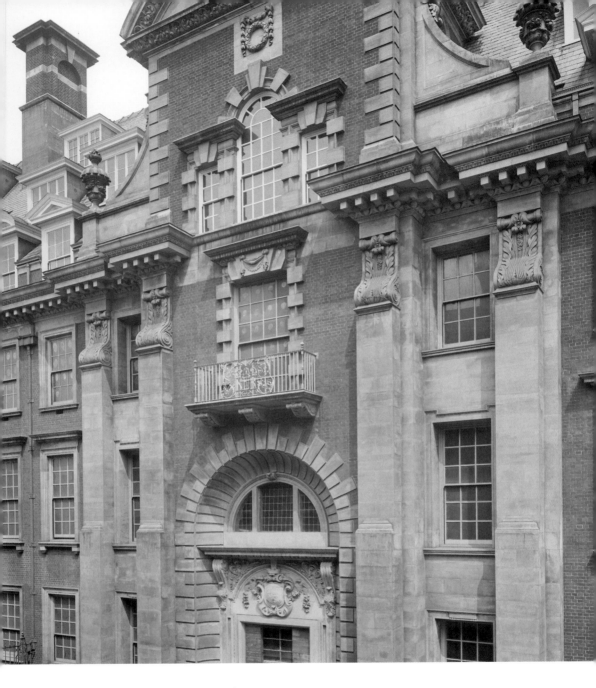

North Eastern Railway Offices, Toft Green

The south-west entrance to the North Eastern Railway offices in 1906. It was George Hudson who established York as a major railway centre. His lasting legacy was the formation of the North Eastern Railway in 1854, headed by Hudson's enemy, George Leeman. York to London could now be done in five hours. Hudson might not have been the most ethical and principled but he was a visionary and made an invaluable contribution to the railways of England.

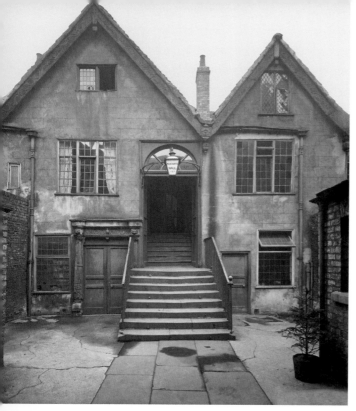

Merchant Adventurers' Hall, Fossgate

This medieval guildhall was a place for the Company of Merchant Adventurers of York to conduct business and socialise. The facade shown in the photograph from September 1917 was later restored, exposing the hall's timber-framed construction. The image below depicts the interior of the courtroom, looking towards the dais. A merchant adventurer was a merchant who risked his own money in pursuit of his trade or craft. The Merchant Adventurers' Guild goes back to 1357 when a number of prominent York men and women joined together to form a religious fraternity and to build the Merchant Adventurers' Hall. By 1430 most members were merchants of one kind or another. They then set up a trading association or guild, using the great hall to conduct their business affairs and to meet socially, to look after the poor in the almshouses in the undercroft and to worship in the chapel.

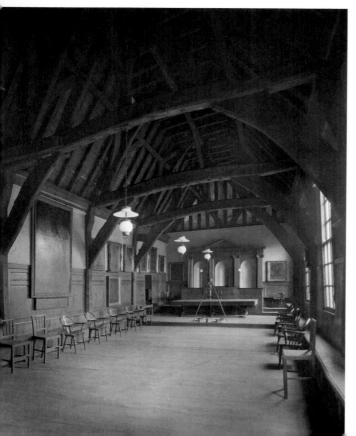

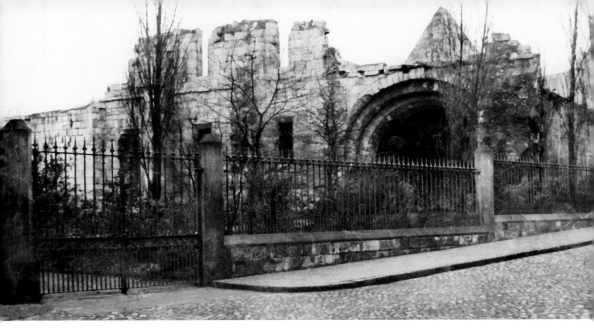

St Mary's Abbey Remains and St Leonard's Hospital, Museum Gardens

St Leonard's Hospital at the entrance to the Museum Gardens in 1854. Below we have a snowy scene looking towards the ruins of the chapel of St Leonard's Hospital. The end of the thirteenth century saw St Leonard's at its zenith. It looked after 230 patients, both men and women: there was free distribution of loaves and herrings at the gates during the week, thirty-three dinners, with eight more for lepers on Sundays, all washed down with fourteen gallons of beer. The 300 prisoners at the castle received a loaf on the Sabbath. Thirty elderly bedesman were given refuge in an almshouse while an orphanage took in twenty-three boys, looked after mainly by women. Two choirmasters taught thirty choristers the three 'r's and music. The modest staff comprised a master, thirteen brothers, four secular priests, eight sisters and six working men.

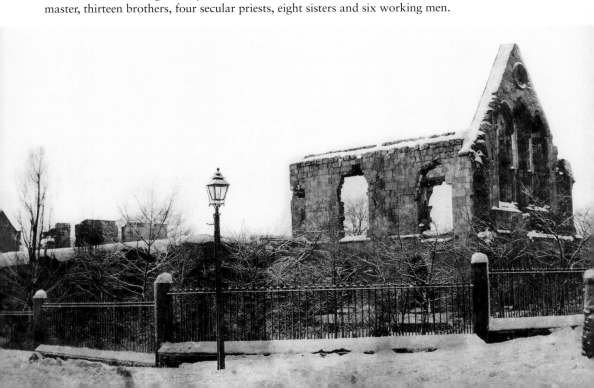

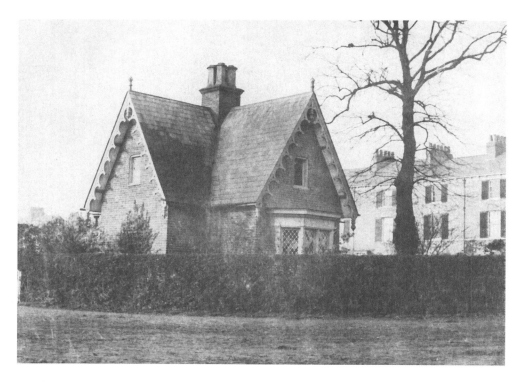

Herdsman's Cottage, No. 159 Mount Vale
The gabled Herdsman's Cottage, No. 159 Mount Vale, with the houses on the north-west side of Mount Vale behind. This single-storey cruciform house was built around 1840. The photo is from 1853. The picture below epitomises the old and new in the city of York, with a twenty-first-century carousel in the foreground and the medieval Clifford's Tower in the background.

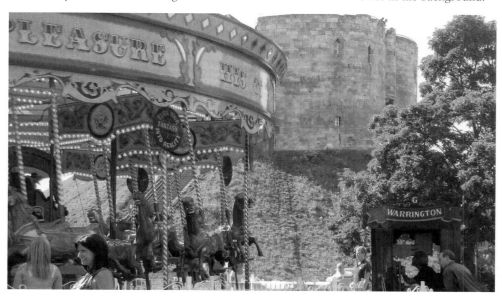

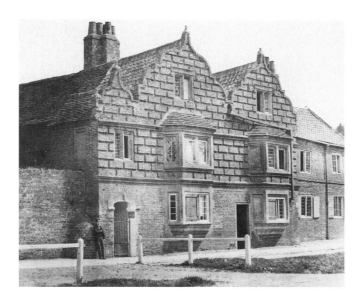

Nos 64–66 Clifton
A boy leaning against the seventeenth-century gabled house at No. 64–66 Clifton. The house is a late seventeenth-century brick alteration to a sixteenth-century timber-framed building. It was restored and altered in 1962. The photograph was taken in 1851.

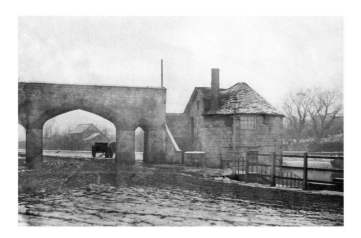

Barker Tower
A wintry view showing the Barker Tower or North Street Postern Tower. It dates from the early fourteenth century, given a new roof in the seventeenth century and was restored in 1840, 1930 and 1970 by the Great North of England Railway. The name derives from the barkers who stripped bark off oak trees to be used by tanners – hence nearby Tanner's Moat and Tanner Row. A chain was slung across the Ouse here as a line of defence and to prevent merchants from entering the city without paying tolls. Uses over the years include a boom tower and a mortuary from 1879.

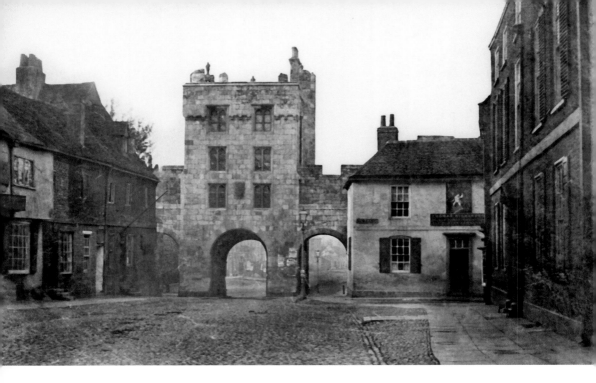

Micklegate Bar
Micklegate Bar from the north-east in 1853, with the now demolished Jolly Bacchus public house on the north side of the gate. The Jolly Bacchus was demolished in 1873. Above we have the Bar from the Micklegate side with the sadly demolished entrance to the Priory below.

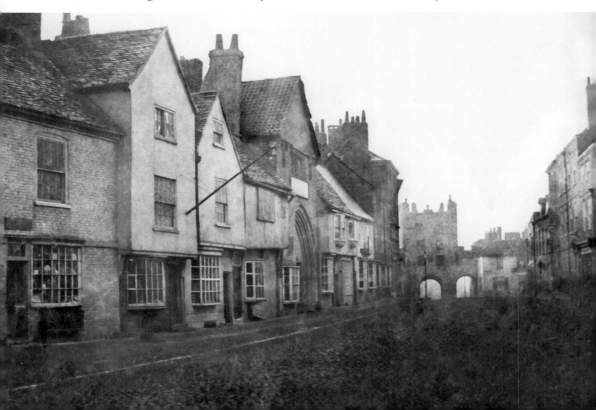

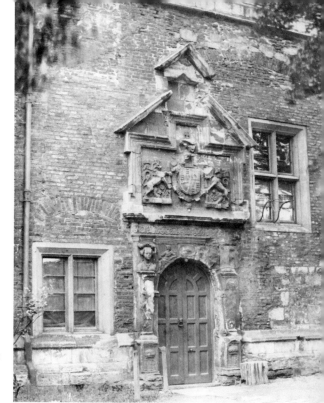

King's Manor, Exhibition Square
The Jacobean doorway on the east front of the east range at King's Manor. At the time the photograph was taken (1853) the former abbot's house of St Mary's Abbey was the Wilberforce School for the Blind. The Wilberforce School for the Blind (also known as the Yorkshire School of the Blind) was established at the King's Manor in 1833. The doorway was originally on the courtyard side of the east range but was moved to the east front in the nineteenth century. In the image below we can see the courtyard of King's Manor.

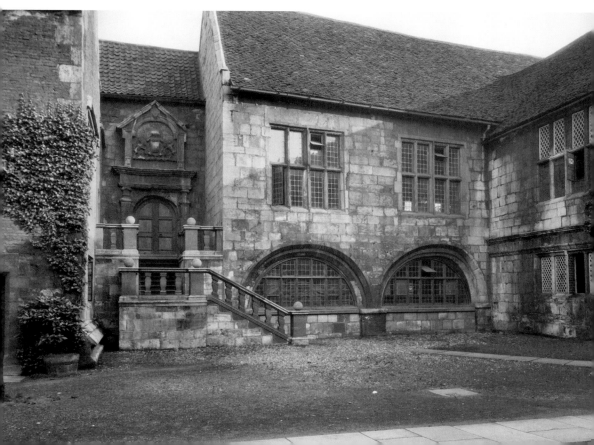

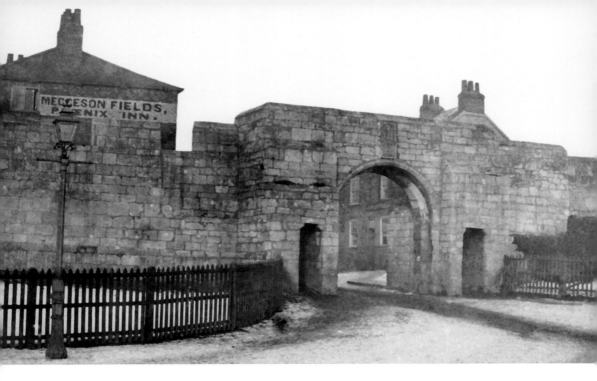

Fishergate Bar

Fishergate Bar in 1853, with the roof of the Phoenix Inn in George Street just visible above the crenelated parapet of the city wall. Fishergate Bar was burnt during a revolt against taxation in 1489. It was subsequently blocked up and was not reopened until 1827, when the cattle market was moved outside the city walls. The name of the Phoenix pub derives from the Phoenix Iron Foundry nearby.

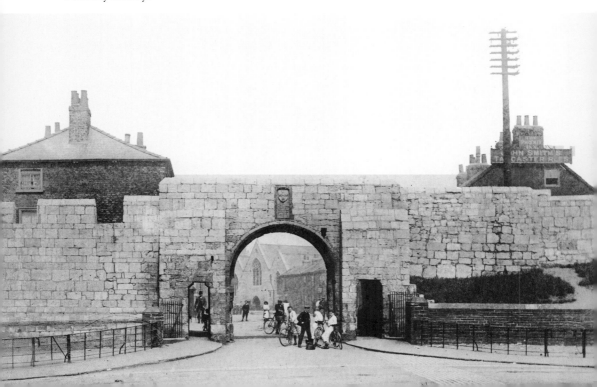

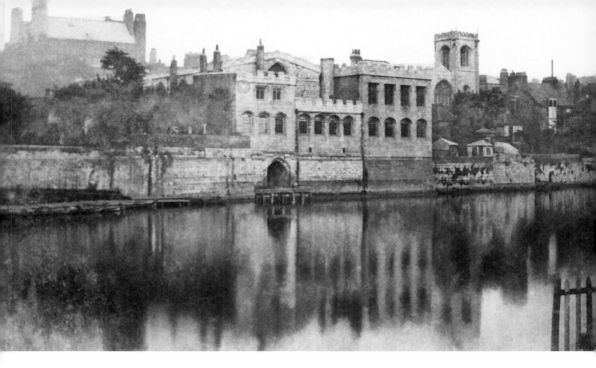

The Guildhall

Looking across the River Ouse towards the Guildhall and Council Hall, with the tower of St Martin's Church visible to the south-west. The Guildhall dates to the mid-fifteenth century but the Council Hall, was added in 1808–09. The subterranean Common Hall Lane passes under the Guildhall – then called Common Hall – to a jetty on the river, originally a continuation of Stonegate. It is clearly visible in the centre of this 1853 photograph. In the bottom photograph we are looking south-east from Lendal Bridge, the Guildhall and the office of the *Yorkshire Herald* on the left bank, with a small motor boat travelling along the river towards Ouse Bridge.

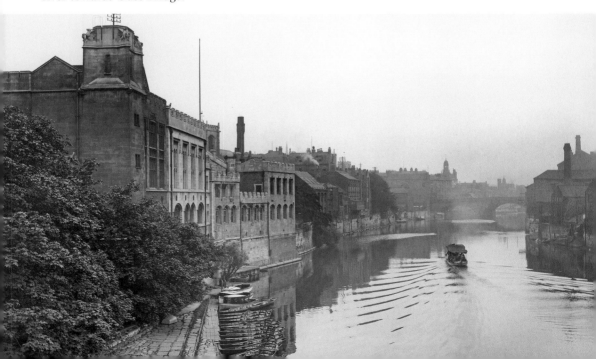

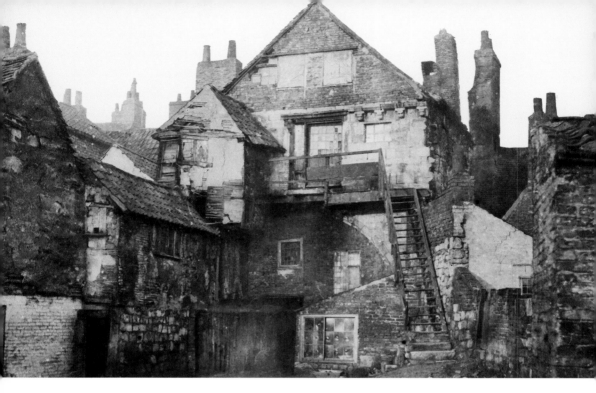

Micklegate

The rear of a tenement building in the area to the south of Micklegate. The inner arch of the former Priory gateway is visible in the wall, next to the staircase to the upper floor. A Benedictine priory, Holy Trinity Priory, was in the area now bounded by Micklegate, Trinity Lane, St Mary's Churchyard and the city wall. The house that incorporated part of the priory's gateway was demolished in 1854 to allow for the creation of Priory Street. Above we have a similar scene with the house in the bottom photo visible in the background of the one above.

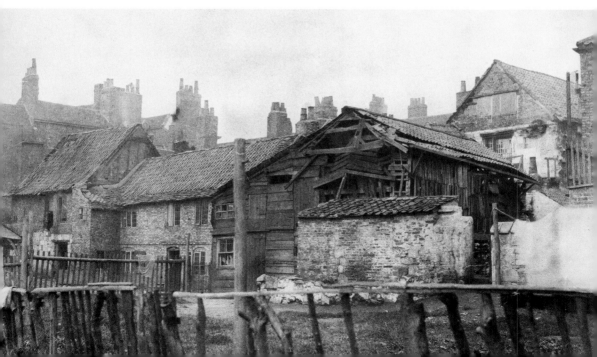

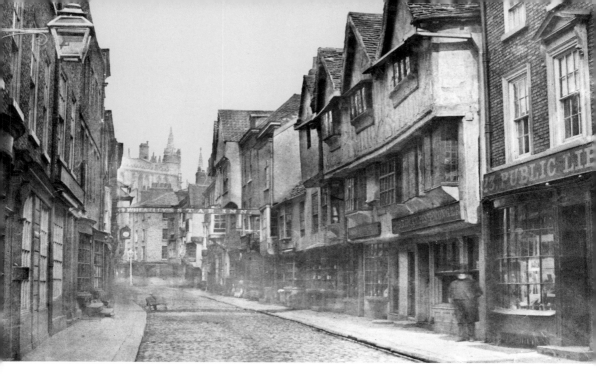

Nos 13–58 Stonegate

Looking along Stonegate, the Ye Olde Starre and its gallows sign and the Public Library at No. 13 are shown. The photo below shows Stonegate on the corner of St Helen's Square, taken outside No. 53 Stonegate around 1910. By common consent Stonegate is one of the finest streets in England, if not Europe, and York's first 'foot-street', pedestrianised in 1971 and paving the way for many more. Stonegate was once famous for its coffee shops (hence Coffee Yard). The old Roman stone paving – hence the name – survives under the cobbles complete with the central gulley for the chariots' skid wheels. It was the Roman Via Praetoria.

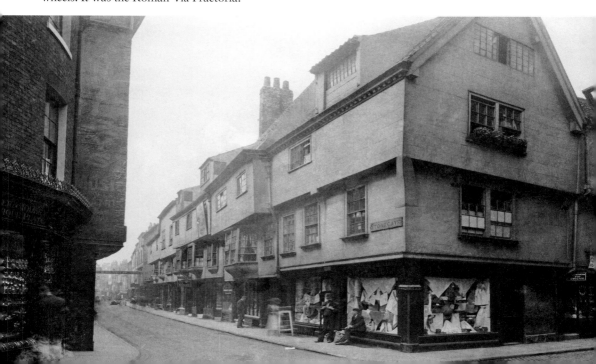

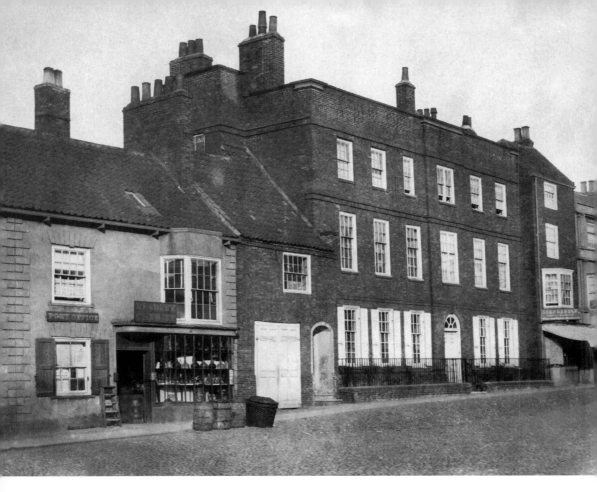

The Post Office and Bradley's Chemists
The post office, Bradley's chemists shop, probably in Lendal. Lendal – formerly Aldeconyngstrete or Old Coney (King) Street – is a contraction of Landing Hill – a reference to St Leonard's Landing, a staithe or landing on the Ouse used to import stone for the building of the Minster.

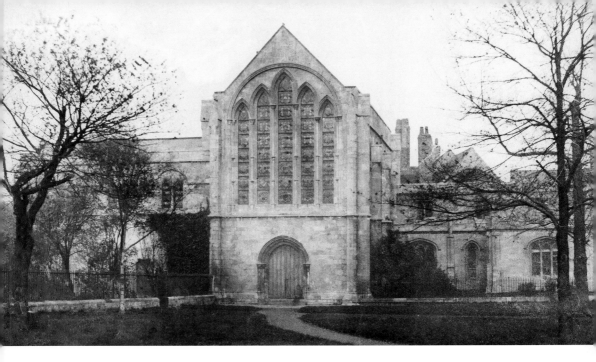

Minster Library, York
The west facade of the Minster Library. Originally it was a thirteenth-century chapel for the episcopal palace before the move to Bishophorpe Palace. It was restored, extended and converted into the library in the early nineteenth century by William Shout.

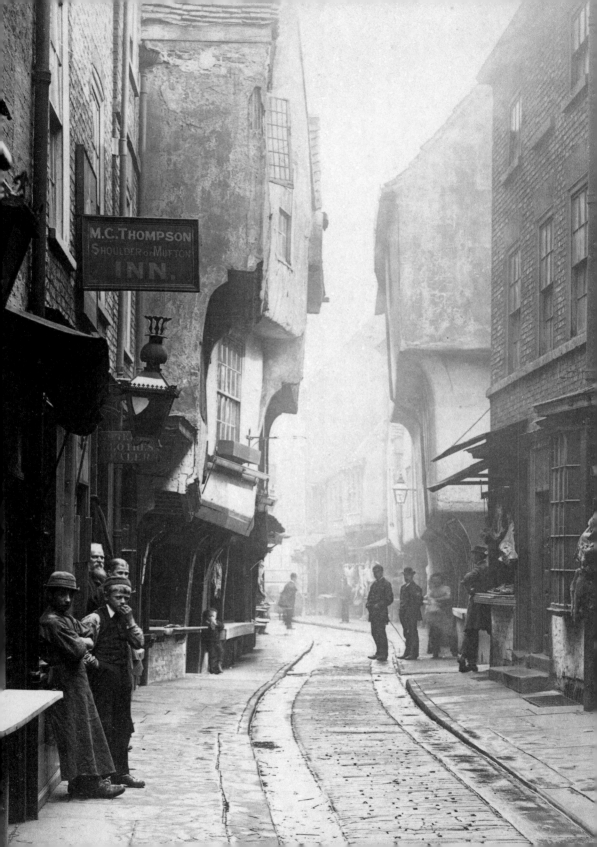

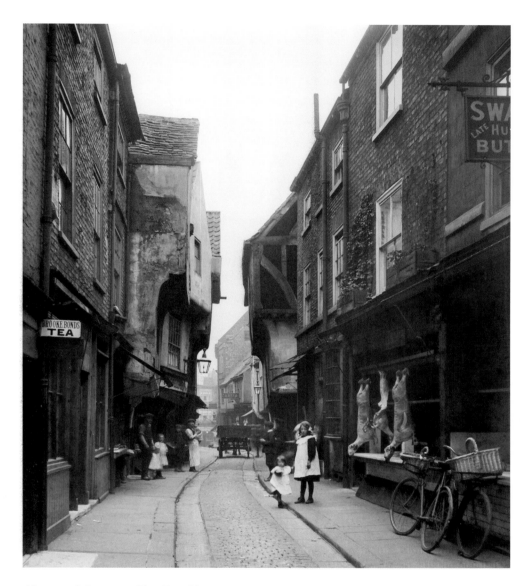

Above and Opposite: The Shambles
The Shambles with the pub sign for the Shoulder of Mutton Inn (landlord M. C. Thompson) hanging in the foreground around 1880. On the right is a similar view in 1910, by which time the beer appears to have changed into tea, with a good shot of the butcher's carcasses. The Shambles was originally called Haymongergate to signify the hay that was here to feed the livestock before slaughter. After that it was called Needlergate for the needles made here from the bones of slaughtered animals. It gets its present name (at first The Great Flesh Shambles) from the fleshammels – a shammel being the wooden board butchers used to display their meat on. They would throw meat on-the-turn, offal, blood and guts into the runnel in the middle of the street to add to the mess caused by chamber pot disposal from the overhanging jetties.

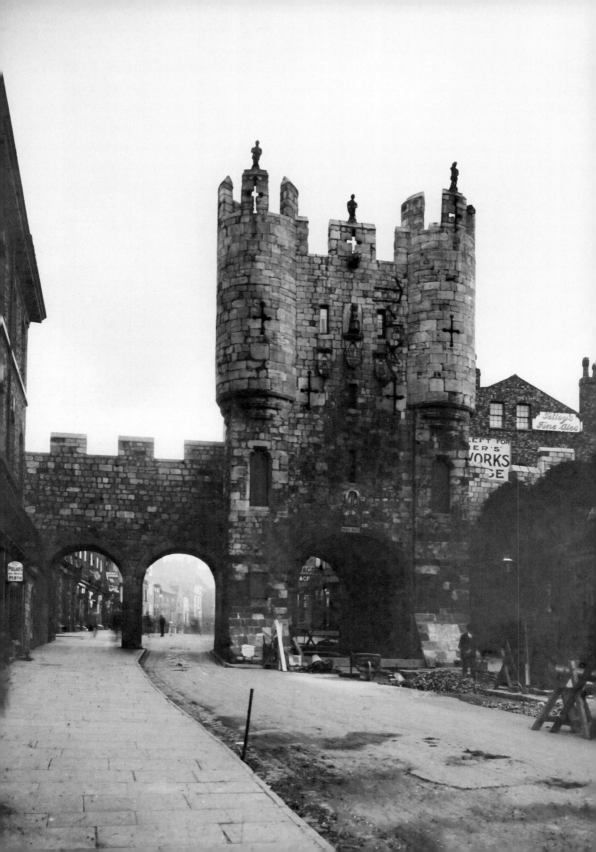

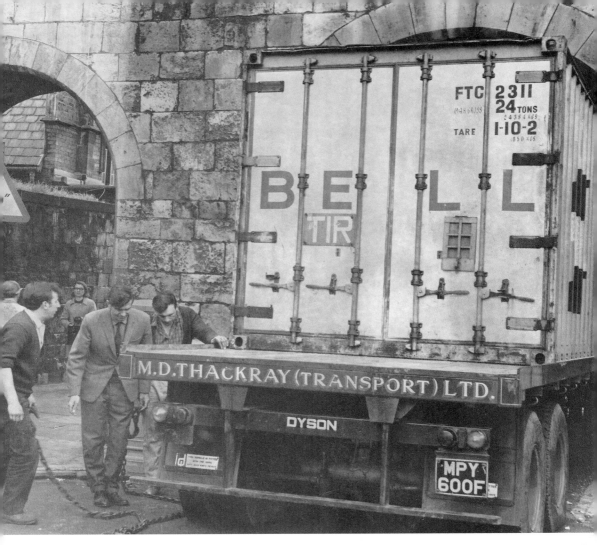

Above and Opposite: Micklegate Bar

Micklegate Bar in 1910, with roadworks being carried out on Blossom Street (opposite).
Above, this 20-foot fertiliser truck was stuck in Micklegate Bar for three hours in October
1969. A spokesman for the council said 'I wouldn't mind if this driver was a foreigner but he
only comes from Malton'.

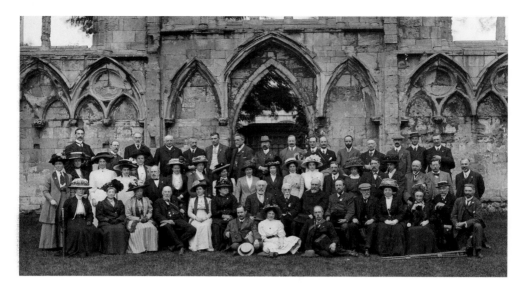

St Mary's Abbey

A group of unidentified men and women pose in front of the ruins of the north wall of the church at St Mary's Abbey in 1910.

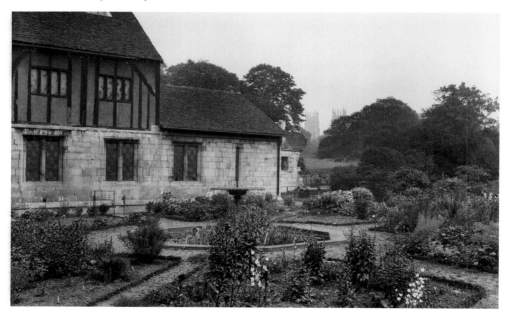

The Hospitium and Water Gate, Museum Gardens

The gardens and fountain to the front of the Hospitium in Museum Gardens. The Hospitium is a fine fourteenth-century half-timbered building that was probably designed both as a guest house for visitors to the nearby St Mary's Abbey and as a warehouse for goods unloaded from the river nearby. There was an Elizabethan knot garden with a central fountain between the Hospitium and the river.

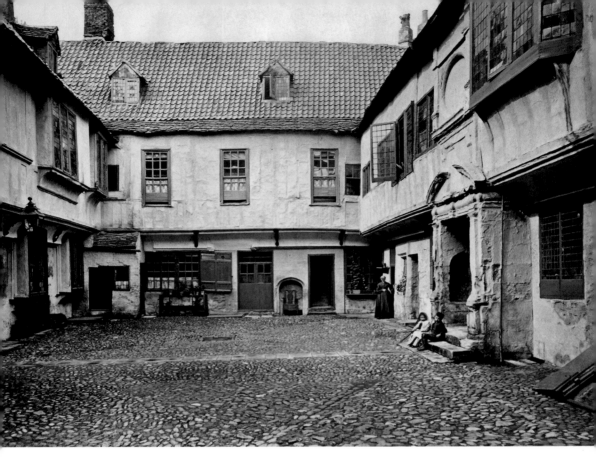

St William's College

The courtyard of St William's College. Originally the House of the Prior of Hexham, it is named after Archbishop William Fitzherbert (St William) and built in 1465 by order of Warwick the Kingmaker. From around 1890 the fifteenth-century half timbering was covered in stucco; it was removed again in 1906. The college was split into tenements at the time but formerly was home to the Minster's Chantry – twenty-three priests and their provost. The priests, in Bedern, had been indulging in 'colourful nocturnal habits' and were re-billeted in the nearby college so that their behaviour could be monitored more closely. One incident involved one of the cathedral freelances hitting a man over the head with the blunt end of an axe.

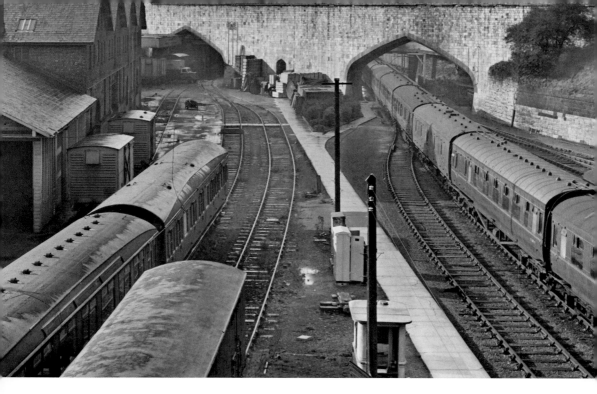

York Old Station

York's second railway station, the old station, was within the city walls until the opening of the third and present station outside the walls. Below we see the old station and the buildings, including the refreshment room, which are now the council offices.

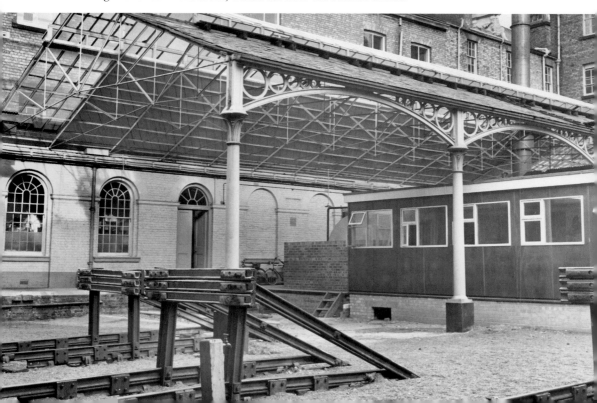

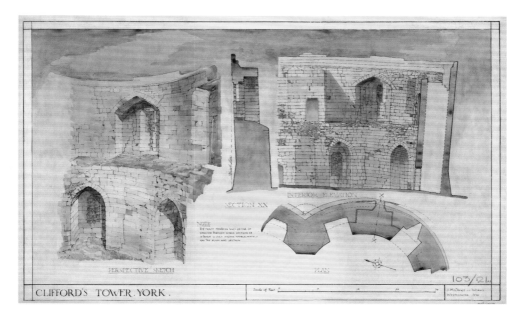

Clifford's Tower, York Castle

Above is a hand-tinted perspective sketch, interior elevation and part plan of the southeast portion of the keep with a section through a window – produced from a pen and ink drawing (Reproduced by permission of Historic England Archive). Although not signed, this is in the style of Frank Baines. Below is a cutaway reconstruction illustration showing the keep at Clifford's Tower as it may have looked after it was constructed in the late thirteenth century. The north-west wall and roof have been 'cutaway' to reveal the interior chambers. The illustration was created by Peter Dunn, but is partly based on an earlier illustration by Peter Snowball.

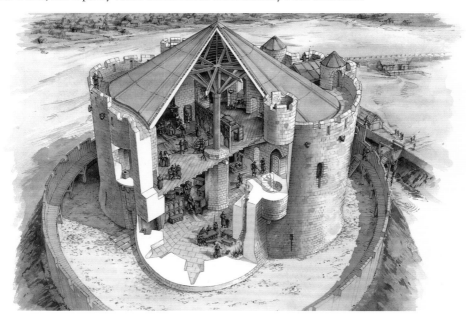

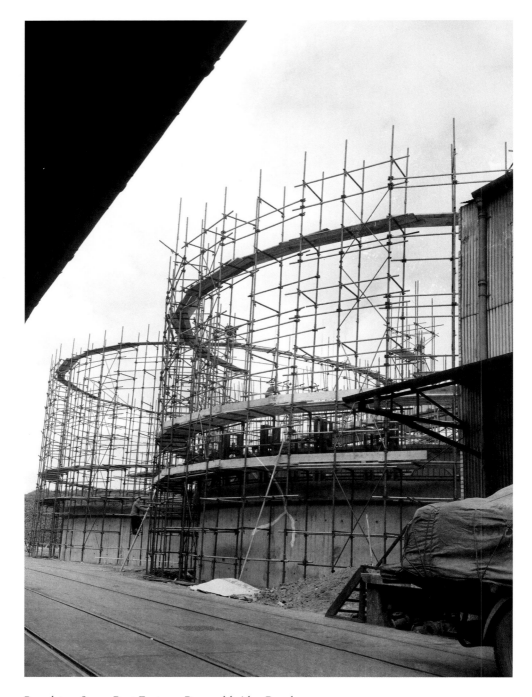

Poppleton Sugar Beet Factory, Boroughbridge Road
The building of two sugar silos at Poppleton Sugar Beet Factory, Boroughbridge Road, in 1955. These pre-stressed, post-tensioned concrete silos were made with a sliding formwork using hydraulic climbing jacks.

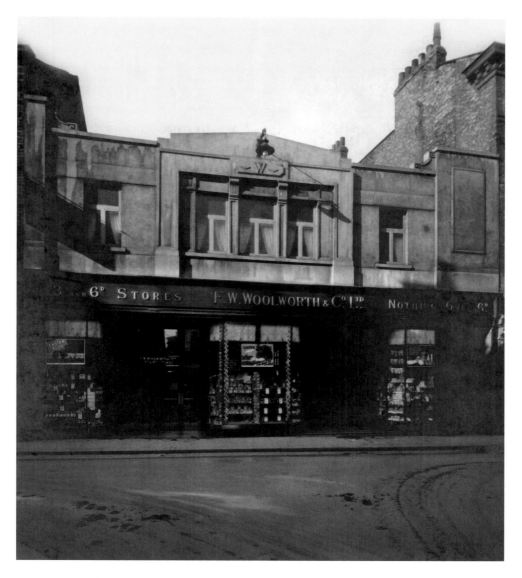

F. W. Woolworth & Co. Ltd, Spurriergate

A front view of the original F. W. Woolworth & Co. Ltd shop on Spurriergate. Originally Backhouse florists were on the site. James Backhouse and his brother Thomas were nationally celebrated nurserymen. Their gardens were collectively called the Kew of the North. They were responsible for the cultivation of numerous rare plants, some of which James brought back from South Africa and Australasia. A particularly striking feature was a twenty-five-foot-high Alpine gorge built with 400 tons of rock, which led to a surge in rockeries all over the country. In 1938 the nurseries were sold to the Corporation, who made them into a park. This lasted until 1946 when it was all covered over. Backhouse had been producing catalogues long before 1821 when the second edition of their pithily titled *Catalogue of Fruit & Forest Trees, Evergreen & Deciduous Shrubs, Ornamental Annual, Biennial Plants, also of Culinary, Officinal & Agricultural Plants* was published.

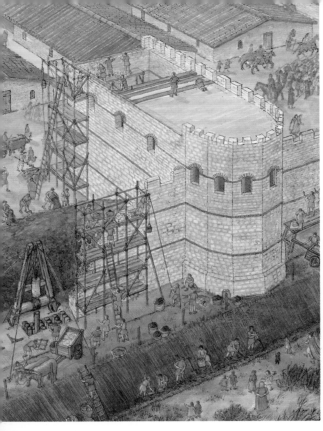

Interval Tower SW5, Eboracum
Legionary Fort, and Principia Basilica,
Eboracum Legionary Fort

An aerial reconstruction illustration
depicting the construction of interval tower
SW5 in the defensive wall surrounding
Eboracum Legionary Fortress in Roman
York. This illustration was reproduced as
a colour plate, and is on the front cover
of the book entitled *Roman York* by
Patrick Ottaway, published in 1993 by
Batsford/English Heritage. The opposite
image shows a reconstruction illustration
depicting the interior of the Principia
Basilica at Eboracum Legionary Fortress,
located just to the south of where the
medieval Minster stands today.

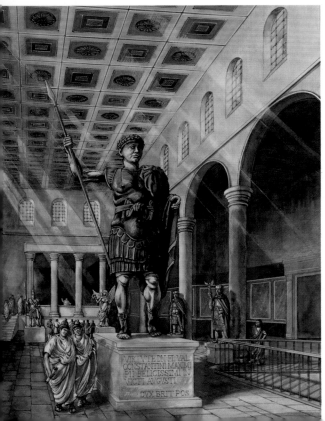

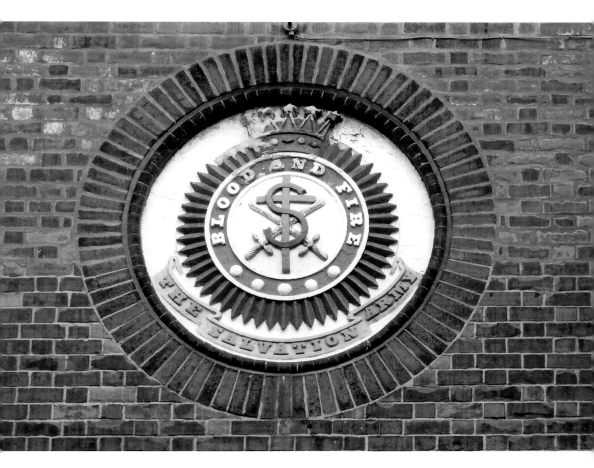

Salvation Army Citadel, Gillygate
The roundel on the front of the Salvation Army Citadel, containing a painted carving of the Salvation Army crest in Gillygate. The Salvation Army has now vacated these premises. Early York meetings were held in a skating rink in Gillygate in 1881. In the following year a corps was built and opened by General Booth in 1883. The building accommodates 2,000 people. A second corps was meeting in North Street in 1905 in the former Wesleyan mission room there. In 1936 the premises of the Wilton Street (later Rise) Methodist chapel were occupied by the Army, and subsequently used as the headquarters of the second corps. In 1909 a branch opened in Hamper's Yard, Walmgate; other outposts existed for some time in Fishergate and Haver Lane, Hungate. Currently homeless itself, the York branch of the Salvation Army is searching for suitable premises for a new citadel. The motto on the old 1882 citadel in Gillygate – the Citidel website tells us – 'Blood and Fire' refers to the blood of Jesus Christ and the fire of the Holy Spirit.

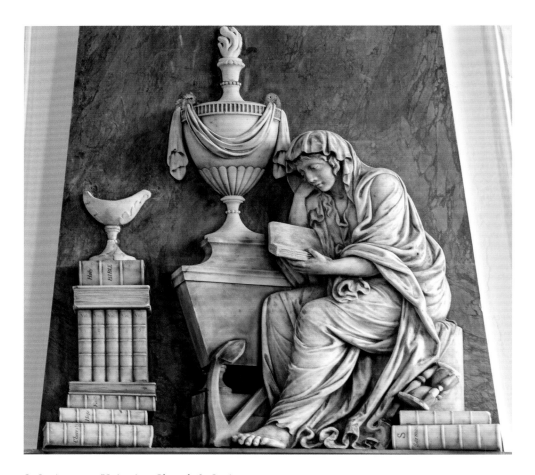

St Saviourgate Unitarian Chapel, St Saviourgate

A detail of a monument to Rachel Sandercock in St Saviourgate Unitarian Chapel, St Saviourgate. It all started with the seventeenth-century Commonwealth Puritans who, after the restoration of the monarchy with Charles II, would meet in private homes to worship God without the traditional rituals of the Church of England. One of these homes was that of Andrew Taylor, 'an opulent merchant' in Micklegate. In 1689, when the Act of Toleration allowed this and other Puritan groups, Lady Hewley, a local lady, and a few others built a brick meeting house in 1693 (in earlier years often called St Saviourgate Chapel, Lady Hewley's Chapel or the Presbyterian Chapel) as a meeting place for this group of dissenting Puritans. It is built, unusually, in the shape of a Greek cross – unique among English churches. The epitaph reads:

Obt. January 27 1790 Ano: Aet. 85
She was a Constant Attendant on Public Worship in this Place
and her Life was Distinguished by Numerous Acts of
GENEROSITY, KINDNESS & CHARITY
But her Record is on High!
In Memory of her Virtues,
and in Testimony of his Esteem,
Her relation WILLIAM CHALONER
Caused this Monument to be Erected.

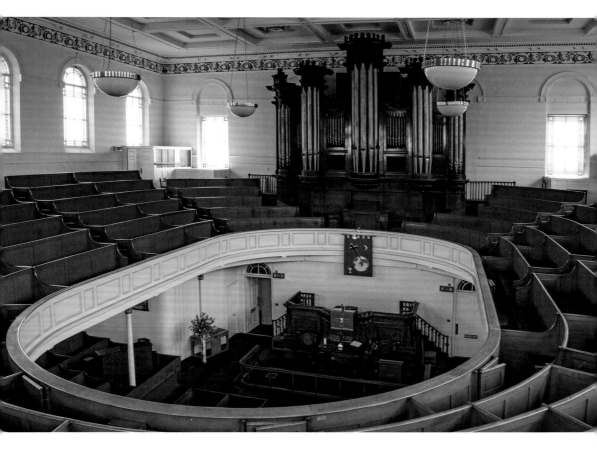

Central Methodist Church, St Saviourgate
An interior view of the Central Methodist Church, St Saviourgate, from gallery level, taken in 2014. Patrick Nuttgens called it 'one of the northern cathedrals of Methodism'. The grandiose chapel was originally known as the Centenary Chapel because it was built in 1840 to mark 100 years of Methodism. The main hall seats 1,500 people. In the 1980s, Centenary merged with Wesley Chapel in Priory Street and has been known ever since as Central Methodist Church. There were, however, dissenters among the Dissenters, who quite wrongly predicted that it would 'prove a waste and howling wilderness'.

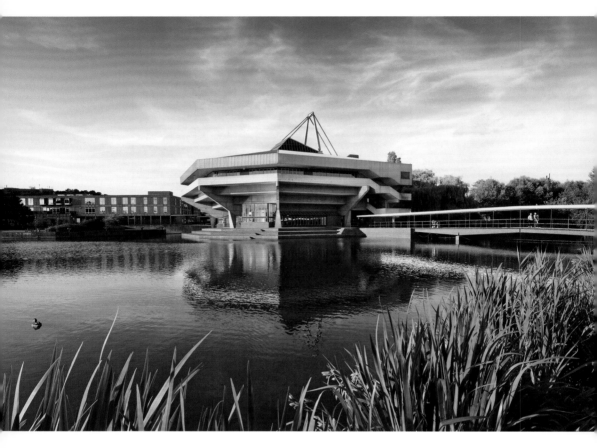

Central Hall, University Of York, Heslington

This image looks over the lake to the Central Hall of the University of York, taken in 2009. Note the solitary duck to the left. The first petition for a university in York was to James I in 1617, followed by other unsuccessful attempts in the eighteenth century, one to annex it to the short-lived existing medical school. In 1903 F. J. Munby and others (including the Yorkshire Philosophical Society) proposed a 'Victoria University of Yorkshire'. What was then the College of Ripon and York St John considered purchasing Heslington Hall as part of a proposed new campus. The campus lake is the largest plastic-bottomed lake in Europe and attracts many waterfowl. The campus also supports a large rabbit population, the hunting of which by students is strictly prohibited. Heslington Hall is a fine Elizabethan manor built by Thomas Eymes in 1568. Eymes was secretary to Henry VIII's Great Council of the North, which had its headquarters in King's Manor. As with other buildings of the time, it was constructed in the shape of an 'E' in honour of Elizabeth I.

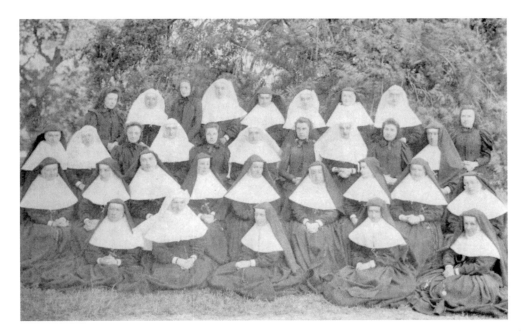

The Convent of the Institute of the Blessed Virgin

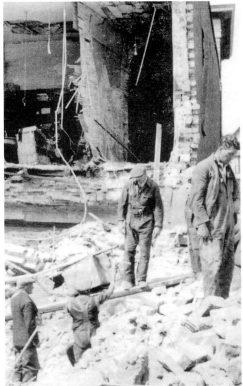

The Convent of the Institute of the Blessed Virgin at Micklegate Bar, on the corner of Nunnery Lane and Ploxam Street (now Blossom Street). The Bar Convent is the oldest lived-in convent in England. It was established as a school for Catholic girls in 1686. For Catholics the seventeenth century was often a harrowing time of persecution – the illegal Bar Convent was necessarily very much a clandestine community. Known as the 'Ladies at the Bar', the sisters wore plain grey day dresses rather than habits to avoid raising suspicion. Nuns were Mrs, not Sisters. The community suffered great poverty, persecution and imprisonment – not just for the faith but also for teaching that faith. The 1942 raids on York, Norwich, Bath, Canterbury and Exeter became known as Baedeker because Goring's staff allegedly used the famous travel guide to select their *Vergeltungsangriffe* (retaliatory) targets – namely three-star historical English cities – in retaliation for the RAF destruction of Lubeck and Rostock. The Bar Convent School was hit killing five nuns including the headmistress, Mother Vincent.

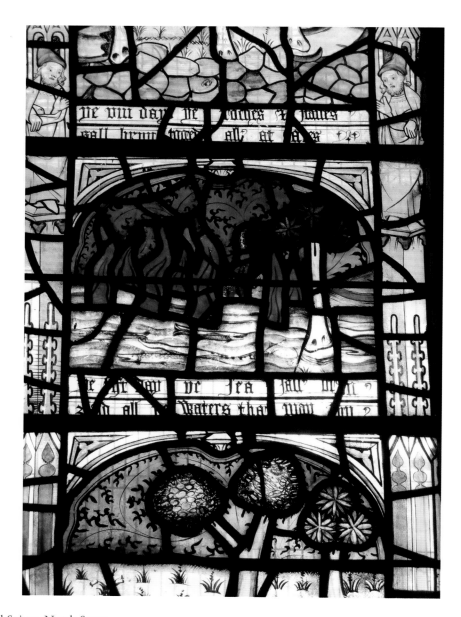

All Saints, North Street

All Saints, North Street, has some of the finest medieval stained glass in Europe that is not actually in York Minster, including the aisle window that shows the Six Corporal Acts of Mercy (as in *Matthew*) and the famous 1410 Doom window (or 'Pricke of Conscience' window), which graphically depicts your final fifteen days on this earth before the Day of Judgement. This is an apocalyptic vision of a world on fire, and is as vivid a depiction of medieval terror and god-fearing repentance as you are likely to see anywhere. The captions are paraphrased (in English, not Latin) from the medieval poem 'The Pricke of Conscience' – unusual for the time in view of literacy levels among congregations and the prevalence of Latin in ecclesiastical settings.

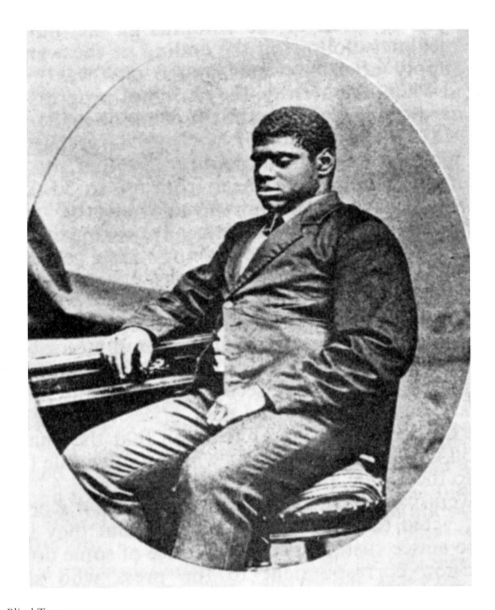

Blind Tom

In 1866 we heard that 'Blind Tom is Coming! Blind Tom, the Inexplicable Phenomenon' who had recently wowed audiences at the St James's and Egyptian Halls in London (*York Herald*, 20 October). He was an ex-slave and a protégé of Charles Dickens, who counted him as a 'valued friend'. Tom had been a 'makeweight' thrown into the deal when his mother was bought by a tobacco planter: 'a lump of black flesh born blind, and with the vacant grin of idiocy'. Notwithstanding, he turned out to be a gifted pianist and a success on the novelty and trick circuit; for example, 'his most confusing feat was to play one air with his left hand, another with his right in a different key, whilst he sang a third tune in a different key again ... experts such as the Head of Music at Edinburgh testified to his accuracy'.

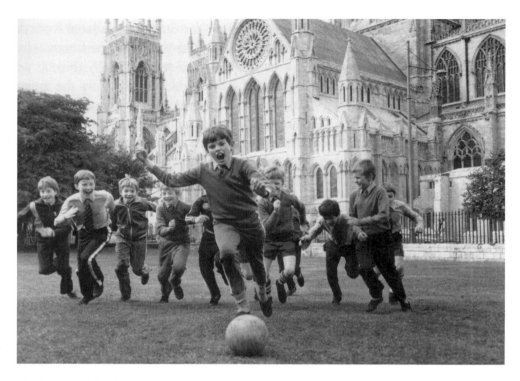

The Minster School
The Minster School – not many football matches can boast a backdrop like this. Originally published in John Roden's *The Minster School, York: A Centenary History 1903–2004*. At the Minster School (the former Song School until 1986), the headmaster in 1962 still 'had a love of the old gym shoe as a disciplinary measure'. Clubs included Song School Loco spotters with visits to sheds at Leeds and Manchester on Wednesdays, stamp collecting, bird spotting and nature rambles.

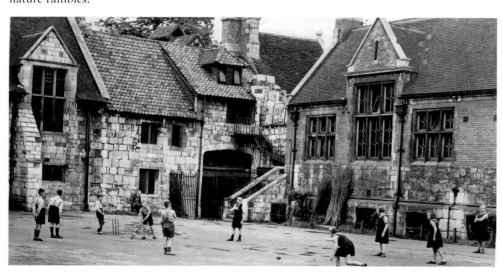

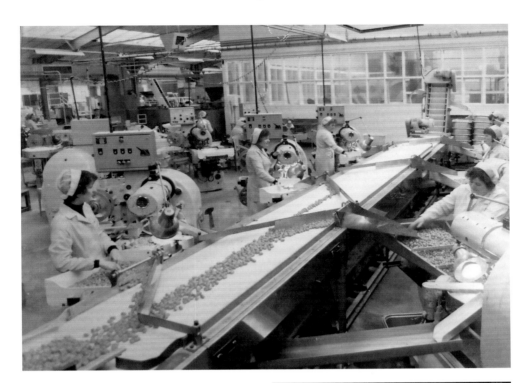

Terry's of York

Terry's moved to their purpose-built Baroque Revival building in 1930 from their Clementhorpe site, which they had occupied since 1862. By 1840 Terry's products were being delivered to seventy-five towns all over England. Apart from boiled sweets, they also made marmalade, marzipan, mushroom ketchup and calves' jelly. Conversation lozenges, precursors of Love Hearts (with such slogans as 'Can you polka?', 'I want a wife', 'Do you love me?' and 'How do you flirt?'), were particularly popular. Chocolate production began around 1867 with thirteen chocolate products adding to the other 380 or so confectionery and parfait lines. Before the Second World War 'Theatre Chocolates' were available with rustle-proof wrappers. The famous Chocolate Orange (which started life as a *Chocolate Apple*) was born in 1932 and at one point one in ten Christmas stockings reputedly contained a Terry's Chocolate Orange. In the 1990s 7 million boxes of All Gold were sold in a year. On the right is the famous Terry's clock, seen here from the inside.

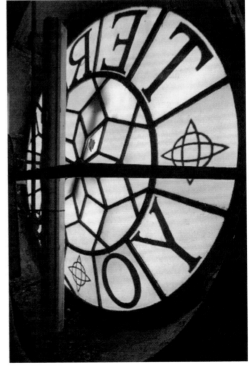

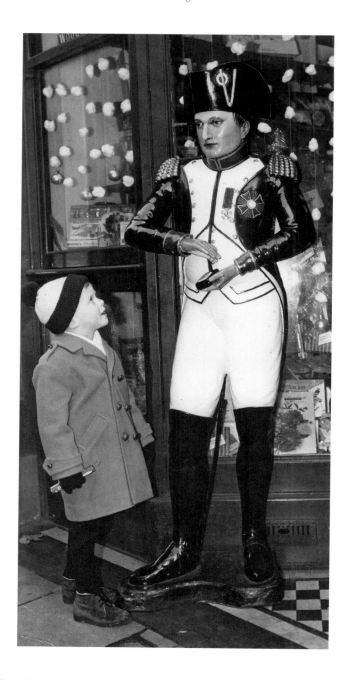

Napoleon

Napoleon: *du 'tabac à priser, monsieur?'* Napoleon arrived in York in 1822, one year after his death on St Helena. He stood sentinel outside this tobacconists in Low Ousegate, H. Clarke, to whom letters were addressed simply as 'Napoleon, York' – and would arrive. In full uniform, he is carved out of a solid piece of oak and was one of three made, selling for £50 each. Apparently he frequently ended up in the River Ouse, courtesy of soldiers garrisoned in York.

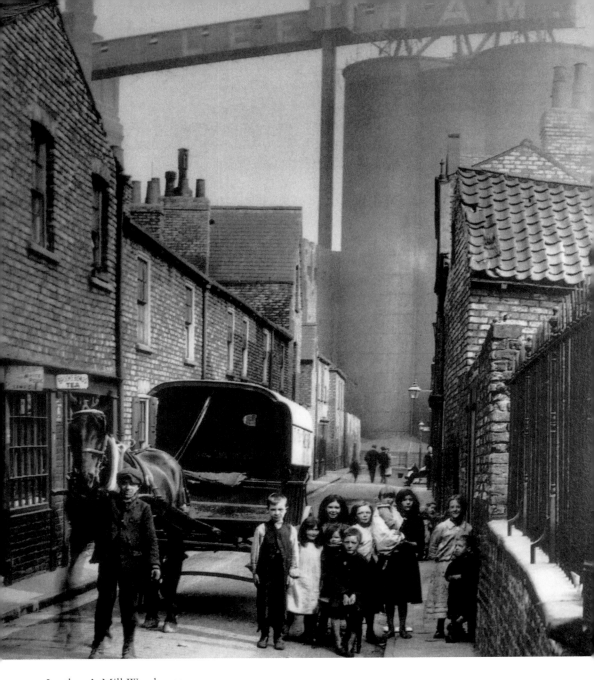

Leetham's Mill Warehouse

Leetham's flour mill from Garden Place, Hungate, in 1904. This was one of the largest flour mills in Europe designed by Walter Penty in 1895 and comprising five storeys and a nine-storey water tower complete with battlements and turrets. It is surrounded on three sides by the Foss and Wormald's Cut. By 1911 more than 600 people worked here. Spillers took it over in 1930 before moving to Hull in 1931 after a fire. Rowntrees bought it in 1937 for cocoa bean storage. It is now luxury apartments.

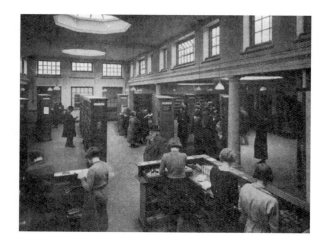

York City Library
York City Library Lending Room in 1934. Originally in Clifford Street, the library in Exhibition Place changed its name in 2010 to the Explore York Learning Centre to reflect a wider range of services and research facilities. The local history collection and archives go back 800 years, with over 20,000 books covering the history of York and its surrounding area, as well as local magazines and journals such as the *Yorkshire Archaeological Journal*, the *Yorkshire Dalesman, Yorkshire Life*, the *Yorkshire Journal*, and *Thoresby Society Publications*.

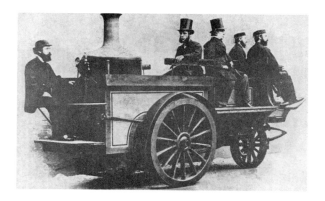

Thomas Cooke
Thomas Cooke on his steam car – second from the left. Thomas Cooke came to York in 1829 and made his first telescope, using the base of a whisky glass for a lens and a tin for the tube. In 1837 he opened his first instrument-making shop at No. 50 Stonegate with a loan of £100 from his wife's uncle. In 1856 Cooke moved into the Buckingham Works built on the site of the home of the second Duke of Buckingham at Bishophill – one of Britain's first purpose-built telescope factories. In 1866 Thomas Cooke branched out into three-wheeled steam cars, which reached the dizzy speed of 15 mph; they were, however, outlawed by the Road Act, which prohibited vehicles travelling in excess of 4 mph. In those days a man with a red flag had to walk in front of any vehicle not pulled by a horse. Cooke fitted his steam engine into a boat and travelled on the Ouse, free of horses and red flags.

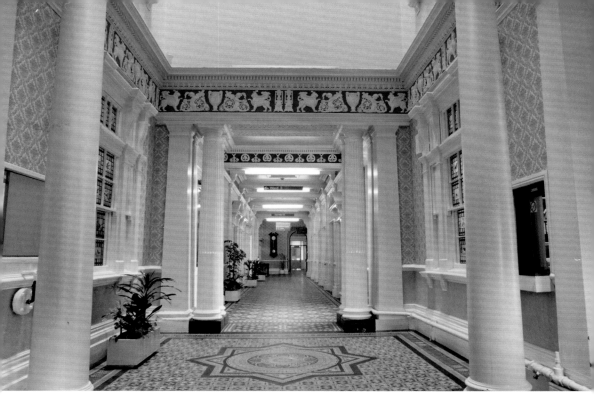

Bootham Park Hospital

Bootham Park Hospital in July 1988. It started life as the Lunatic Asylum in 1777. Part of the asylum burnt down in 1814 with the tragic loss of four patients, and patient records – somewhat convenient, perhaps, as the fire coincided with allegations aimed at the management of the asylum. All staff were dismissed and replaced. In the same year a visiting magistrate had reported that the 'house is yet in a shocking state ... a number of secret cells in a state of filth horrible beyond description' and the floor covered 'with straw perfectly soaked with urine and excrement.' In 1904 it was renamed Bootham Park Hospital.

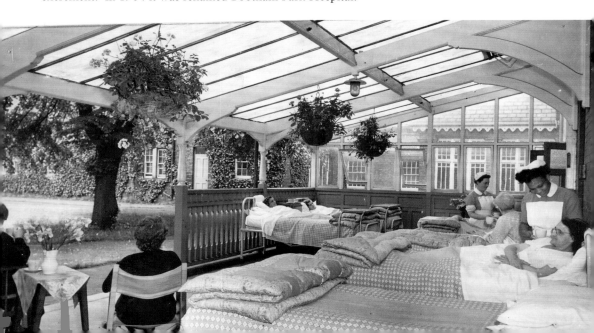

The Poor Clares

These forty nuns came to York from Bruges. The first convent of the Sisters of the Second Order of Saint Francis was Plantation House in Hull Road in 1865. They moved to the obscure St Joseph's Monastery in Lawrence Street in 1873. Until recently they lived there behind 20-feet-high walls, got up at 5.00 a.m., lived in silence, were vegetarians and cultivated a 6-acre garden to make themselves largely self-sufficient. The convent comprised cloisters, cells, chapel and refrectory. The remaining eight Poor Clare Colettines have now moved to Askham Bryan. The convent's Mother Abbess sought permission from the Vatican for the move and admitted to mixed feelings: 'It's only bricks and mortar', she said. The photo shows a camera-shy Poor Clares.

Davygate
Davygate in 1929 showing the Davy Hall restaurant built in 1904 in art nouveau style, featuring a magnificent stained-glass canopy. Below the Labour Exchange in Parliament Street in 1905.

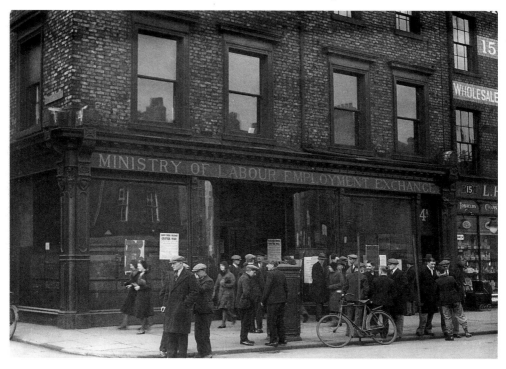

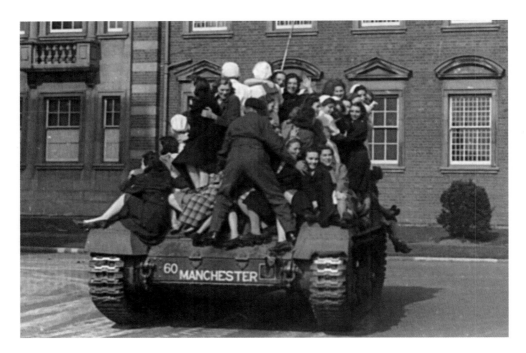

York in the Second World War

Above, a Second World War fundraising tank at Terry's. Below, bombed houses after an air raid in 1942.

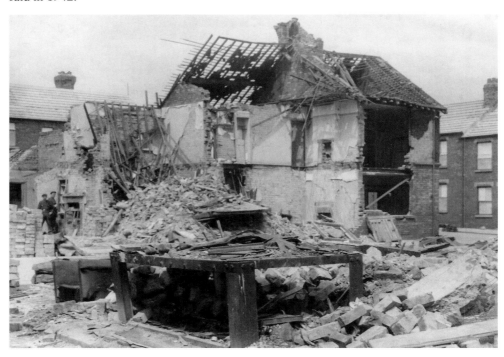

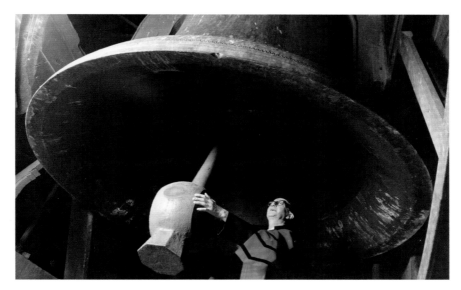

York Minster's 'Great Peter'
Here, Verger John Daly has a close look at York Minster's 'Great Peter' in 1992. At 10.8 tons, it is the third heaviest bell in the UK. Originally cast in 1845, it was recast in Loughborough in 1928.

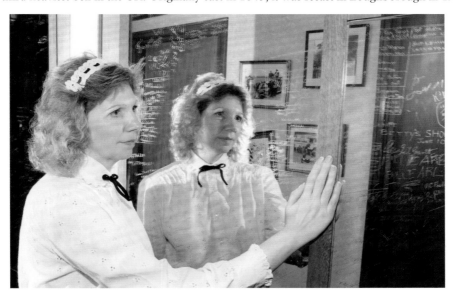

Bettys Mirror
Polishing the famous Bettys Mirror. On 1 February 1945 J. E. McDonald was the first of 600 airmen to scratch their names on the mirror at Bettys during the Second World War. Also known as Bettys Bar, it was a regular haunt of the hundreds of airmen stationed in and around York including many Canadians from No. 6 Bomber Group. One signatory, Jim Rogers, borrowed a waitress' diamond ring to scratch his name on the mirror. Many have returned to reflect on their efforts, although many of the signatories did not survive the war. The mirror is still on display downstairs in Bettys.

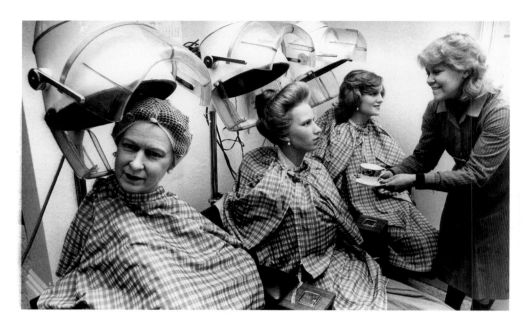

The Princess Royal

Hairstylist Janet Brown attends to some posh visitors in 1984. The Princess Royal looks less than impressed with her cup of tea. The models were on a day out from the Friargate Wax Museum.

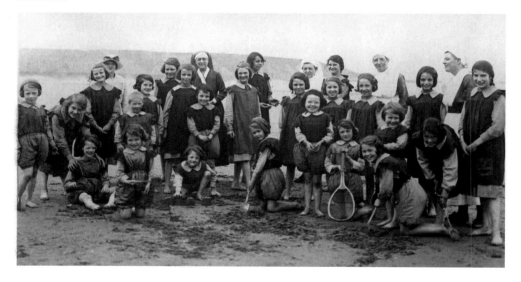

St Stephen's Orphange, Trinity Lane

Happy girls from St Stephen's Orphanage, Trinity Street, on a day trip to Filey in July 1919. The orphanage was founded in the 1870s originally in Precentor's Court, moving to Trinity Lane and then to The Mount in 1919 – it closed in 1969. Its aim was to accommodate and educate poor girls who had lost one or both parents. The image is part of the Evelyn Collection.